# Keith Haring

Edited by Darren Pih

With contributions by Paul Dujardin, Tamar Hemmes,
Hans-Jürgen Lechtreck and Darren Pih

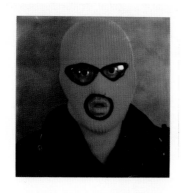
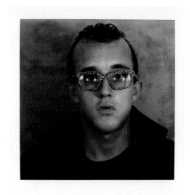

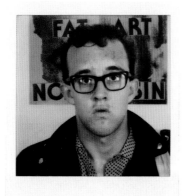
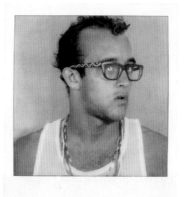

53RD STREET

FIFTH AVE.

←FIFTH AVE→
←MADISON AVE.

# Contents

Tseng Kwong Chi,
*Keith Haring,
New York Subway*
c.1984, Muna Tseng
Dance Projects, Inc

# Directors' Foreword

Helen Legg
Director, Tate Liverpool

Paul Dujardin
CEO and Artistic Director, BOZAR,
Centre for Fine Arts, Brussels

Sophie Lauwers
Director of Exhibitions, BOZAR,
Centre for Fine Arts, Brussels

Peter Gorschlüter
Director, Museum Folkwang, Essen

American artist Keith Haring (1958–1990) emerged as part of the legendary New York art scene of the 1980s. During this time he became renowned for his collaborative approach and political activism as much as for his deceptively simple visual language – including radiant babies and barking dogs – which fused art historical influences with the energies of his culture: street art, space travel, video games, hip hop and robotics. This exhibition, initiated by Tate Liverpool and developed in partnership with the Centre for Fine Arts (BOZAR) in Brussels and Museum Folkwang in Essen, examines how Haring united the realms of uptown high art and downtown street culture, in turn expanding the legacies of pop art to address the most urgent political and social issues of his time. It highlights the importance of the city – the streets of New York that became the infrastructure for the production and display of much of his work.

The exhibition explores how Haring was compelled to speak of and for a new generation, creating a sophisticated vocabulary of iconic and politically viral visual motifs to reach a wide and diverse audience. His work addressed issues that remain relevant today, including the dangers of dictatorship, homophobia, racism, nuclear annihilation, drug addiction, the excesses of capitalism and environmental degradation. Haring's work as an AIDS activist and educator remains his most essential legacy.

Created during his dazzling twelve-year career, the exhibition brings together over eighty paintings, drawings and sculptural objects, tracing the influence of abstract art and theoretical ideas, as well as Japanese and Chinese calligraphy and Egyptian hieroglyphs. Haring's famed subway drawings, created in their thousands in the early 1980s, exemplify his commitment to creating a socially resonant art for all. Augmented by a vast array of posters, flyers, photographs and video documentation, the exhibition brings to life the socio- and subcultural energy of late-1970s and 1980s street culture, which inspired the artist's work.

Both BOZAR and Museum Folkwang are delighted to collaborate once again with Tate Liverpool. During the 1990s, BOZAR presented monographic exhibitions including Roy Lichtenstein and Andy Warhol. Keith Haring provided a logical continuation of this commitment to presenting exhibitions of important American artists. BOZAR is delighted to present Haring to audiences in Brussels, especially in light of the numerous Belgian exhibitions during the artist's lifetime. Likewise, Museum Folkwang have enjoyed important collaborations with Tate Liverpool, including the Maria Lassnig exhibition in 2017.

A touring exhibition of this level of ambition and innovation requires the support and generosity of a number of collaborators. First and foremost, our thanks go to Julia Gruen, Annelise Ream and Anna Gurton-Wachter at the Keith Haring Foundation, whose support and guidance have been essential to our endeavour.

We would also like to thank a number of individuals who have generously shared their time and supported the development of our exhibition. These include Charlie Ahearn, Todd Alden, Björn von Below, Ben Brown, Robert Carrithers, Suzanne Geiss, Barbara Gladstone and Caroline Luce, Sandy Heller and Chloé K Geary, The Heller Group LLC, Young Kim (Estate of Malcolm McLaren), Joe La Placa, Lio Malca, Jose Martos, Hans and Stephanie Mayer, Samantha McEwen, Richard McGuire, Gianni Mercurio, Enrico Navarra and Emma Chapoulie-Danjean, Jérôme and Emmanuelle de Noirmont, and Pierre-Henri Kleinbaum (Noirmontartproduction), Kenny Scharf, Herb and Lenore Schorr, Tony Shafrazi and Hiroko Onoda, Per Skarstedt and Bona Montagu, Samuel Tob, Muna Tseng, Cindy Lee and Kyla Raskin (Estate Archive of Tseng Kwong Chi), Christophe Van de Weghe and Pierre Ravelle-Chapuis, Larry Warsh and Taliesien Thomas, as well as individuals who prefer to remain anonymous.

Our deepest thanks go to curator Darren Pih, who has worked tirelessly to reimagine the work of Keith Haring for a contemporary audience and who will reintroduce Haring's energy and brilliance to a whole new generation. Darren has been expertly supported by Tamar Hemmes, Assistant Curator, who has offered her creativity and relentless diligence to the project. The realisation of the exhibition at Tate Liverpool has, in addition, been supported by the energies and talents of our Registrar and Production Manager Daniel Smernicki, and our Art Handling team led by Jenny Hunter. The exhibition and public programme at Tate Liverpool is supported by the Keith Haring Foundation, Liverpool John Moores University and the Keith Haring Exhibition Supporters group. We would also like to express sincerest thanks to Christian and Florence Levett for supporting the realisation of this publication.

We are grateful to Alberta Sessa and Hans-Jürgen Lechtreck, for co-curating the exhibition in Brussels and Essen, respectively, and to their teams for their consistent and careful work in implementing the project at both venues.

The exhibition would not be possible without the generosity of those who have made works by Keith Haring available for this exhibition and we would like to thank them for their ongoing support.

Finally, we would like to thank the team at Tate Publishing: Alice Chasey, Project Editor, and Bill Jones, Production Manager, and the designer Lorenz Klingebiel, for producing this beautiful publication, which will function as a lasting legacy of the exhibition.

The exhibition has been made possible by the provision of insurance through the Government Indemnity Scheme. Tate Liverpool would like to thank HM Government for providing this and the Department of Digital, Culture, Media and Sport and Arts Council England for arranging it.

# The Public Has a Right to Art

by Darren Pih

*My paintings, themselves, are not as important as
the interaction between people who see them and the ideas
that they take with them after they leave the presence
of my painting.*[1]

Writing in his journal in October 1978, shortly after
arriving in New York to enrol at the School of Visual Arts
(SVA), Keith Haring outlined a fundamental artistic
philosophy that propelled a blazing career, cut short by
his AIDS-related death in 1990. Haring envisaged creating
a public art that would be 'experienced by as many
individuals as possible with as many individual ideas
about the given piece with no final meaning attached.'
Through this, he anticipated his social role as a spokes-
person for a new generation of Americans. Rather
than making 'bourgeois art for the few', he was compelled
to create socially relevant art accessible to all.[2]

 Haring worked at a time that saw an expanded
definition of what constituted public art. He was primarily
known for drawings and bold, often large-scale paintings,
combining a range of art historical and philosophical
influences with the cultural energies of the age: street
art, activism, performance, rap and hip-hop, space travel,
video games and robotics. Alongside these, he produced
public murals, occasionally made with and for children.
The widening of the definition was brought to life by
Haring's public performance of creating his works: he
made drawings in the New York subway stations, as well
as engaging in activism and distributing printed posters
in public spaces. Personal-political subjects – including
feminism, gay rights and racial equality – entered the
language of artistic production in Haring's lifetime,
reflecting the energy of the mid- to late-1960s counter-
culture and its concomitant global protest movements.
Haring learned about these social changes through the
background noise of television and from *Life* magazine

1 *Keith Haring Journals*, New York
and London 2010, p.40
(First published in the United
States by Viking Penguin, 1996).
2 Ibid., p.18.

pictorial essays while growing up in rural Kutztown, Pennsylvania. While he was probably unaware of the relationship between these changes and the revolutionary art by figures including Carolee Schneemann and Jack Smith, who performed and displayed work in unconventional art spaces in 1960s New York, Haring benefited from its after-effects after relocating to New York's East Village in 1978.

Haring's significance today rests on his status as an activist and public figure as much as on his role as an artist. His career was intense and concise, spanning the 1980s. In some ways, he extended the ideals of the 1960s and its culture of protest and collectivism, while regenerating the legacies of pop art. His work remains a conduit through which we can better understand the period's most vital social and political priorities and concerns– from homophobia to racism, to the excesses of capitalism – many of which remain relevant today. His work as an AIDS and HIV activist and educator remains his most essential, political legacy. Haring's relatable imagery embodied a new optimism associated with mainstream popular culture of the early to mid-1980s. Graspable in a heartbeat, his works were displayed in places where they would trigger reactions from the widest possible audience.

Tseng Kwong Chi,
*Keith Haring Drawing on glass* 1985,
Muna Tseng Dance Projects, Inc

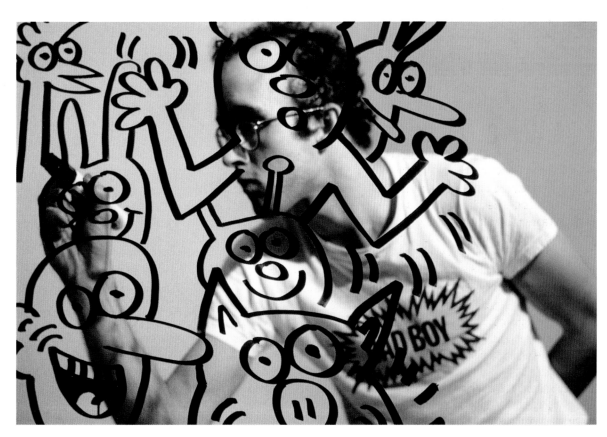

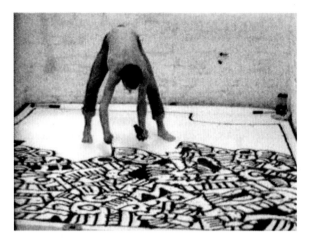

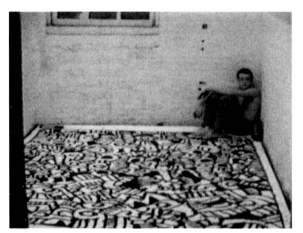

Notions of public-ness and performance are consistent concerns in Haring's work. He grew up with a love of drawing and cartooning. By the age of twenty, he had already formulated a visual language reflecting his wide-ranging interests. His formal education began two years before, in 1976, at the Ivy School of Professional Art in Pittsburgh, a commercial arts school. Convinced his destiny lay in being a fine artist rather than a graphic illustrator, he dropped out after two semesters. However, he continued to work and study independently, spending time in the library at the University of Pittsburgh. There he became interested in abstract expressionist painting, as well as artists associated with the art brut movement including Pierre Alechinsky and Jean Dubuffet.[3] In art brut, Haring saw how the energy and spontaneity of children's art could be harnessed in the hands of a mature artist. He became convinced that art should be direct, unprejudiced and accessible, akin to the art of children.[4] In 1978, he exhibited works at Pittsburgh Center for the Arts, including large-scale, all-over drawings of geometric patterns rendered in fluid, bold black lines, showing Dubuffet's influence. He also created what he termed 'painted environments', with drawings, discarded painting fragments and other media hung freely in the space, aiming to create a more immersive art experience.[5]

In autumn 1978, Haring moved to New York to begin studying at SVA. It was a gear-change, as his studies coincided with his becoming a vital contributor within the vibrant downtown arts scene, centred on the East Village. With its unique history of activism, social reform and racial diversity, by the late 1960s the neighbourhood was experiencing a flourishing of venues including experimental theatres, avant-garde cinemas and poetry workshops, all hewn from the fabric of the burgeoning counterculture. In the wake of the economic and political volatility of the 1970s, which almost bankrupted the city, rent was also cheap, enabling a community of artists to live and work in close proximity far beyond the mainstream art world. Between 1980 and 1987, over one hundred, mostly short-lived, galleries emerged in the East Village. Many were run by artists out of storefronts, lending an energy of DIY entrepreneurialism, characteristic of contested

*Painting Myself into a Corner* 1979, Video, black and white with sound; digital transfer, Collection of the Keith Haring Foundation

inner-city areas in the early stages of regeneration.[6] For Haring, the scene was also a backdrop to self-realisation. Raised in conservative Kutztown with his sexuality under wraps, Haring was able to allow his uncensored self to emerge within the openly gay culture of the East Village.

During his time at SVA, Haring was exposed to theories associated with performance and video art. It was a phase of rapid artistic self-discovery; his journals record his flow of thoughts and his grappling with new ideas and philosophies, as he examined how they related to his own approach. He read vociferously and stated that his 'constant association with writers, dancers, actors, musicians etc. forces me to see my intentions/concerns in relation to theirs.'[7] In 1978, Haring ventured into public urban space for the first time, creating a significant but lesser-known project, which is preserved through photographic documentation. These photographs show torn, debris-like fragments of Haring's abstract paintings taped to lamp posts, newspaper kiosks and trash cans, thus interacting with the texture and palette of the city.

His video experiments of this period warrant particular attention. For example, *(F) Phonics* 1980 presents a semiotic play of fragmented linguistic sounds. In the video we see Haring's friends including Drew Straub, Kenny and Tereza Scharf and Min Thometz Sanchez stepping up one by one to voice individual phonemes, clearly chosen at random, in front of the text equivalent on the back wall. While drawing on the fundamental elements of communication, Haring's cutting and repetition of the individual sound elements creates an aurally meaningless cacophony. For Haring, the video reflected an interest in the performative nature of language, exploring the 'juxtaposition of words and images or sounds and images to formulate results that require the participation and individual interpretation of the viewer'.[8] The disco video portrait *Tribute to Gloria Vanderbilt* 1980 provided a way for Haring to examine his own self-image and visualise himself on screen as a performing subject. For him, its effects were psychological, providing 'a whole other concept of self and ego, and an objective way of looking at and being comfortable with yourself'.[9] As well as making *Video Clones* 1979 with the dancer Molissa Fenley, Haring became interested in documenting the very 'act' of painting as a form of choreography. Video shows Haring lining the walls and floor of his studio at SVA with large sheets of paper, which he fills with an environment of energetically expressed painted strokes and interconnected lines. Haring described his approach as 'body involvement' painting, requiring a repertoire of learned physical

3   Another key influence was hearing Christo talk in Pittsburgh in 1978. The artist spoke about the *Running Fence* project (1972–6), introducing Haring to the notion that an artwork could have conceptual force yet be temporary and environmental in scale and mode of communication.

4   In 1980, Haring would refer to Dubuffet on the invitation for an exhibition, *Anonymous Art*, which he organised at Club 57: 'I am for an art which would be in immediate connection with daily life which could start from our daily life and which would be a very direct and sincere expression of our real life and real moods.' Cited in Elisabeth Sussman, 'Songs of Innocence at the Nuclear Pyre', *Keith Haring*, exh. cat., Whitney Museum of American Art, New York 1997, p.12.

5   Haring stated: 'these environments were created to induce some reaction from the viewer. [They] can be experienced by anybody, anywhere. It is universal and is capable of reaching all levels of life.' *Keith Haring Journals*, 2010, pp.36–7.

6   For an account of the East Village art scene, see Dan Cameron, 'It Takes a Village', *East Village USA*, exh. cat., New Museum of Contemporary Art, New York 2004, pp.41–64.

7   *Keith Haring Journals*, 2010, p.39.

8   Haring quoted in Synne Genzmer, 'Performing the Signal: On Keith Haring's Video Works', Lucy Flint (ed.), *Keith Haring: 1978–1982*, exh. cat., Kunsthalle Wien, Vienna and Contemporary Arts Center, Cincinnati, OH 2012, p.123.

9   Cited in John Gruen, *Keith Haring: The Authorized Biography*, New York 1991, pp.39, 44.

10  Describing what he termed 'video paintings', Haring talked of 'painting myself in a corner ... I am becoming much more aware of movement. The importance of movement is intensified when a painting becomes a performance.' *Keith Haring Journals*, 2010, p.20.

movements, as would a dancer.[10] We might associate these experiments with Allan Kaprow's account of Jackson Pollock's painting as being centred on bodily ritual and interaction, as part of the blur of art and life emerging from the Happenings of the early 1960s.[11]

At the same time, Haring created collages juxtaposing words and images. These reflected his interest in applying semiotic theories 'in ways that applied to visual things – to images rather than to words'.[12] At this time, he also responded to the writings of William S. Burroughs, after happening upon the Nova Convention symposium at the Entermedia Theater (now an East Village cinema), attended by luminaries including Allen Ginsberg, John Giorno, Patti Smith and Burroughs himself.[13] Haring would make collages using words 'cut up' from newspaper headlines, which he rearranged using chance processes to create provocative messages – 'REAGAN SLAIN BY HERO COP', or 'POPE KILLED FOR FREED HOSTAGE' (p.63). Haring photocopied the collages and fly-posted them on the street, addressing what he termed the 'performance aspect of language'. During the same period, artists including Jean-Michel Basquiat and Jenny Holzer, were similarly energising the New York streets with street art and fly-posted subversive media messages.[14]

Ultimately, Haring believed his experiments with language-based art stemmed from his obsessive need to make paintings that were both socially resonant and communicative. He became interested in expressing himself through tacit knowledge with ideas expressed using symbols rather than words. For Haring, the meaning of an image would be constituted not by its own capacity, but through an articulation or interaction with others.[15] In his final journal entry of 1978, he describes making a large floor-based work in his studio, whose doors were opened directly onto the street:

> Many people would take time to stop and watch or discuss it with me ... It was wonderful to hear vastly different opinions, ideas, comments on the same piece ... The main thing that impressed me was the 'kinds' of individuals who would stop and talk to me. They were *not,* for the most part, gallery-goers ... There is an audience which is being ignored, but they are not necessarily ignorant. They are open to art when it is open to them.[16]

Haring perceived that the most vital art was being expressed in the gritty social context of the street, and in no-budget venues such as the Mudd Club. He responded to the hyper-stylised letterforms of graffiti on the streets,

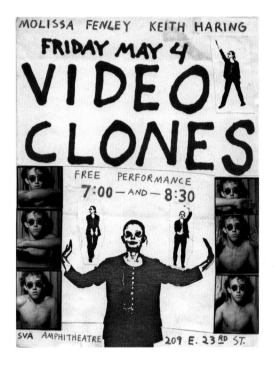

11  Allan Kaprow, 'The Legacy of Jackson Pollock', in Allan Kaprow, *Essays on the Blurring of Art and Life*, ed. Jeff Kelley, Los Angeles 2003, p.5.

12  Semiotics is the study of signs and symbols as part of a theory of communication. Its basic principle is that a sender codes a message (or image) which is transmitted with the receiver decoding it into intelligible meaning. Through his studies at SVA, Haring was familiar with the theories of French semioticians including Umberto Eco, who believed that a single message could be decoded by the receiver in myriad ways and by reference to a diverse system of conventions and social conventions.

13  This also shows in the influence of artist Bill Beckley who taught Haring at SVA, see Gruen 1991, p.54. On Haring's language-based collages and videos, see Raphaela Platow, 'Holding Up a Frame', in Flint (ed.) 2012, pp.82–6.

14  Gruen 1991, p.55.

15  Platow 2012, p.86.

16  *Keith Haring Journals*, 2010, pp.40–41.

regarding it as urban calligraphy – resembling traditional Japanese and Chinese painting – while also discerning in its expression an automatic mind-to-hand flow like that found in the abstract paintings of American artist Mark Tobey.[17] He also admired the 'literary graffiti' created by Jean-Michel Basquiat, who Haring befriended shortly before dropping out of his studies at SVA.

Additional exposure for Haring came through Fashion Moda, a gallery in the Bronx founded by Stefan Eins in 1978, and through artists' collectives such as Colab (Collaborative Projects). In some ways, these groups continued the activities pioneered by artists including Gordon Matta-Clark associated with the site-specific, post-studio generation of the early 1970s.

One of Haring's key contributions in this vibrant post-punk milieu was as a convenor of exhibitions at Club 57. Founded by Stanley Zbigniew Strychacki in February 1978 and located in the basement of a Polish church on St Marks Place, Club 57 was an artist hang-out and venue for performance, poetry readings, live music, film screenings and visual art, helping to launch the careers of such luminaries as Ann Magnuson (who curated the performance programme and managed bookings), Klaus Nomi, Kenny Scharf, John Sex and Tseng Kwong Chi. Its atmosphere was provocative and sexually liberated, revelling in stylistic anarchy, improvisation and hedonism. Haring was a ready performer, as seen in 'Acts of Live Art' which he staged in June 1980. A documentary image shows him holding up a television frame and speaking into a microphone. Rather than being a passive receiver of new media technology, Haring instead became an active contributor and partic-ipant within his culture. Some of his, typically one-night, exhibitions include the *Club 57 Invitational* in May 1980. The Club's democratically created and wildly interdisciplinary programme was often politically-attuned, reflecting a pool of shared experience within an age of heightened social awareness and activism.

In the summer of 1980, Haring experienced an overwhelming urge to return to drawing. He executed his draw-ings quickly, his lines flowing freely and instinctively, created without hesitation. His visual vocabulary – a dictionary of images – arrived seemingly fully formed with clearly understandable meanings:

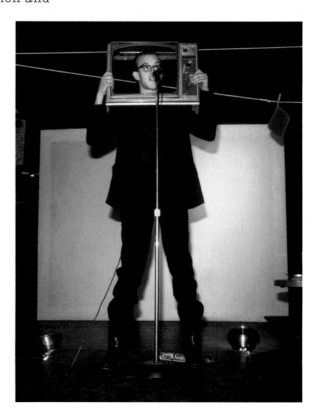

Joseph Szkodzinski, *Keith Haring performance as part of 'Acts of Live Art'*, June 1980, at Club 57

barking dogs, robots, angels, TV sets and flying saucers resembling Mexican sombreros. These archetypal symbols of modern life appeared alongside those of ancient antiquity: pyramids and Coptic urns and Christian symbols including crosses and snakes, reflecting Haring's loosely religious upbringing. That year, Haring also began his famed subway drawing series, executed in white chalk on the blank rectangles of black paper used to cover expired advertisements on the New York subway stations. Documented by photographer Tseng Kwong Chi, whom Haring had met in the East Village, these unsigned works and the public performance of their illegal making helped raise Haring's profile as a media phenomenon.

Haring's cartoon-like imagery is apparently simple in its optimism – schematic outlined figures run up and down stairs, animated by nervous energy. By eliminating texture, spatial depth and the emotional connotations of colour, Haring instead directs our focus to the expressive potential of posture and movement, presenting familiar experiences as well as dream-like scenarios. There is an undeniable humanity in these de-individuated, unisex figures, who seem to express a fundamental truth about an essential spirit of life. Time and again, Haring's drawings focus on a figure perhaps enthralled by the energies of modern technology or hip-hop music, or conversely threatened by some ominous ideological, economic and physical force – even nuclear annihilation, as seen in the *Poster for Nuclear Disarmament* 1982 (p.91). Haring writes: 'The problem facing modern man is the increasing power of technology and its misuse by those in power who only wish to control.'[18]

In 1981, Haring presented one-man exhibitions of drawings at Club 57, Westbeth Painters Space, and P.S. 122. These early exhibitions presented an overabundance of drawings shown salon-style, with many works displayed in close proximity to one another. The important exhibition *New York/New Wave* at PS1, curated in 1981 by Diego Cortez and featuring Haring, was, similarly, installed in a visually overloaded manner. These installations reflected the energy of the urban environment out of which Haring's visual language evolved. Since Haring's drawings reflected those he was creating on the New York subway, his exhibition had an aura of street art, like graffiti. In December 1981, writing in *Artforum,* the American art critic and poet Rene Ricard hailed Haring and Basquiat as the most original artists at the birth of a new decade. In particular, he saw their work as an echo of the street and club culture told through the immediate urban vernacular of hip-hop music.[19]

Energy – expressed through physical movement or political, social or sexual transformation – was a primary

17 Haring writes: 'The forms I was seeing were very similar to the drawings I was doing … This being 1978–9, the war on graffiti hadn't really begun yet. So the art was allowed to flourish into something amazing.' Cited in Gruen 1991, p.44.
18 *Keith Haring Journals*, 2010, p.114.
19 Rene Ricard, 'The Radiant Child', *Artforum*, December 1981, pp.35–43.

theme in Haring's work. Haring seemed to embody energy, manifested through his unceasing work ethic, his restlessness and resourcefulness. His art illustrated energy through the cartoon motion marks emanating from his running men. He wrote: 'The physical reality of the world as we know it is motion.'[20] Elsewhere he described his drawings as depicting 'the transfer of energy from the flying saucer to the human to the animal via sex or zapping or whatever'.[21] Haring drew piles of television sets forming 'a situation of communication, a transformation of energy', perhaps transmitted from artwork to viewer.[22] Yet, overwhelmingly, the works – especially large-scale drawings and paintings – speak of a transfer of energy from artist to picture surface.

In 1982, Haring presented his first exhibition with Tony Shafrazi Gallery, in New York's Soho. For this, he produced works in collaboration with LA II (aka Angel Ortiz), a young graffiti artist he had befriended. Gallery representation and the demands of the art market triggered a shift in Haring's approach, leading him to make large-scale paintings on vinyl tarpaulins and offbeat, punky painted objects including discarded doors and pieces of furniture, as well as fibreglass and terracotta vases. For Haring, tarpaulins reflected the commercial and industrial aesthetic of the street and were chosen as an act of resistance to the perceived elitism and perceived value of canvas painting.

Haring typically commenced the making of his works by painting a frame near to the edge of the picture surface, familiarising himself with the physical dimensions of the work to be created. We might regard this frame – painted, for example, at the perimeter of a square of vinyl tarpaulin – as defining an area for action. Many of the 'techno-primitive' figures in Haring paintings, fittingly, appear to be dancing, reflecting the hip-hop music he heard and danced to at clubs including the Paradise Garage. According to the artist and SVA tutor Barbara Schwarz, his work had 'syncopation, a kind of beat he must have also found in the clubs'.[23] The vivacity of his imagery in works made during the mid-1980s is rooted in an oscillation between ancient and modern culture, often staging 'mechano-erotic figures ... fornicating break dancers, computer-headed DJs, maskheaded monsters and multi-limbed bodies and mutating genitalia'.[24] These works are clearly distinct from many of the painterly and conceptual tendencies of much late-twentieth-century painting and sculpture. Yet, without doubt, they constitute one of the few examples of a truly accessible and popular art that synchronised with the quicksilver changes, paradoxes and opportunities of late-twentieth-century American culture.[25]

*Untitled* 1981–2,
Acrylic paint
on wood, 180.3 × 40,
Collection
Richard P. Emerson

Early in his career, Haring addressed how he might facilitate a broader interaction between artist and audience, by stretching and diffusing the material, economic, historical and social parameters that traditionally govern our experience of looking at art.[26] As a student, he wrote of moving 'toward a work of art that encompasses music, performance, movement, concept, craft and a reality record of the event in the form of a painting'.[27] Perhaps the clearest expression of this combining of different art forms was *Long Distance* 1983, a performative collaboration with the choreographer and dancer Bill T. Jones, staged at The Kitchen in New York. In it, Jones performed on a stage while Haring created drawings as a live backdrop. 'The music was the sound of his brush against the paper', declared Jones, 'and my feet on the floor, my breathing.'[28] That same year, on the occasion of his first UK exhibition, at Robert Fraser Gallery in London, Haring literally painted Jones, covering the dancer's body with his signature modern hieroglyphs.

By the mid-1980s, Haring was a media phenomenon, his name and imagery globally recognisable. He travelled internationally, creating over fifty public murals and opened his New York and Tokyo 'Pop Shops', in 1986 and 1987 respectively. This shift from counterculture figure to pop art superstar shows the mentoring influence of Andy Warhol, who Haring met in 1983. Warhol set a precedent for how a visual vocabulary – the distinctive line, palette and iconographic identity of a body of work – could be cloned and used in a range of different applications, facilitating its reintegration into mass culture.[29] Haring's imagery was dispersed through clothing, record sleeves and the platforms of mass media, as well as through endorsements and collaborations with pop figures including Madonna, Grace Jones, Malcolm McLaren and Vivienne Westwood.

Haring's art found a second life through the platforms of mass media such as television, enabling it to have global effect. He described making works that create energies, transmitted through nodes or connectors, facilitating an unbroken contact with the viewer. 'I gather information from (technological) sources,' he wrote, 'channel it through my own imagination, and put it back into the world. I am continually trying to find new ways to bring these things into the world and to expand the definition of what an "artist" is.'[30] The theoretician Sarat Maharaj asks how we might consider 'works, events, spasms, ructions that don't look like art and don't count as art, but are somehow electric, energy nodes, attractors, transmitters, conductors of new thinking, new subjectivity

20  *Keith Haring Journals*, 2010, p.10.
21  Peter Belsito, 'Keith Haring: Graffiti Artist and Painter', in Peter Belsito (ed.), *Notes from the Pop Underground*, Berkeley 1985, p.100.
22  Haring, cited in Robert Farris Thompson, introduction to *Keith Haring Journals*, 2010, p.xix.
23  Gruen 1991, p.38. The term 'techno-primitivism' is taken from Sussman 1997, p.20.
24  Sussmann 1997, p.20.
25  Ibid., p.24.
26  *Keith Haring Journals*, 2010, p.84.
27  Ibid., p.20.
28  Bill T. Jones, cited in Gruen 1991, p.95.
29  Haring wrote that Warhol 'addressed the phenomena of the camera and the recorded image in a way that Duchamp only hinted at.' *Keith Haring Journals*, 2010, pp.155–7.
30  *Keith Haring Journals*, 2010, p.117.

and acting that visual artwork in the traditional sense is not able to articulate.'[31] In this sense, one of Haring's primary achievements was to create new forms of distribution and participation – from public murals to activism to the Pop Shop – widening our participation with visual art and culture.

In 1988, Haring was diagnosed as being HIV positive. By the mid-1980s, the creeping horror of the crisis unfolding in cities and communities across the world was becoming apparent. Many of Haring's friends and acquaintances were affected. He was aware that his time would be short. In March 1987, he wrote: 'I always knew, since I was young, that I would die young. But I thought it would be *fast* (an accident, not a disease). I live every day as if it were the last. *I love life.*'[32]

Haring's social conscience compelled him to continue painting to save others. Works that were formerly orgiastic celebrations of open sexuality and hedonism were re-envisioned as phantasmagoric omens of mortality. The imagery in his *horror vacui* paintings such as *Untitled* 1986 shows the influence of the visual grotesque found in the work of William Burroughs, reflecting Haring's

*Untitled* 1982, Two panels: Acrylic paint on wood, each: 300 × 212, Courtesy Editions Enrico Navarra

18

awareness of the AIDS epidemic. Haring's work is part of a broader resurgence of interest in neo-expressionist figurative painting in the 1980s, whose practitioners included Basquiat as well as Francesco Clemente (whom Haring had befriended in 1987). Some paintings, meanwhile, are straightforwardly activist, such as the *Silence=Death* painting of 1989 (p.106). That year he also created a poster for ACT UP (AIDS Coalition to Unleash Power), the international direct action and HIV/AIDS advocacy organisation. Haring also told of his predicament through his signature cartoon style. One of Haring's mostly elegant and harrowing works is a series of ten drawings, dated 24 April 1988 (pp.104–5), in which Haring casts the AIDS virus (HIV) as a malevolent 'demon sperm'.

Haring died of AIDS-related complications on 16 February 1990. In his lifetime, his popularity and perceived commercialism led to critical dismissal. Yet, with hindsight, Haring's populist reach does not undermine his position as one of the late twentieth century's most significant artistic figures. His interviews and writings demonstrate his sensitivity to 'high art' both past and present, yet he chose to immerse himself in the vernacular, public culture that provided many of the references for his images. In the same way as French artist Fernand Léger made work that was synchronised with the rise of modern industrial society in the early twentieth century, Haring's work reflected a convergence of the emerging cultural energies of his age. His was a truly public art that has contributed to defining our culture of the past forty years.

As the 1980s recede into memory – and perhaps into nostalgia – we survey this period with melancholy for a generation lost by the AIDS epidemic. While it was an era of excess and decadent expenditure, we must celebrate the 'do-it-yourself' entrepreneurialism, the vivid creativity and resilience – the fun – that conjured a socially-conscious living culture on the streets and subways of the East Village.

Haring thought beyond the constraints of the traditional art world and gallery system, to bring his art to the widest possible audience. He capitalised on his profile to raise awareness of the most urgent issues of his and our time. In an age of protest – this time of social and cultural division – Haring remains a model for how an artist can be a unifying figure and a symbol of open generosity and optimism **DP**

31 Cited in Bettina Funcke, *Pop or Populus: Art between High and Low*, New York 2009, p.148.
32 Author's italics, *Keith Haring Journals*, 2010, p.163.

# Art is for Everyone

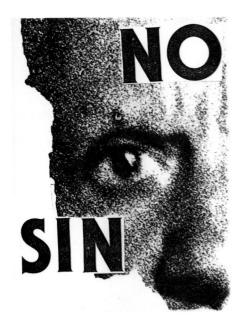

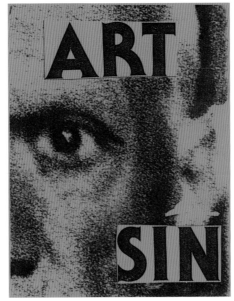

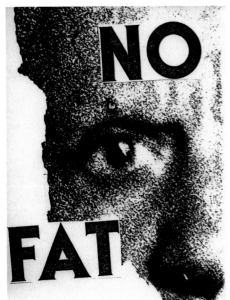

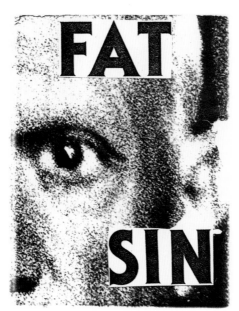

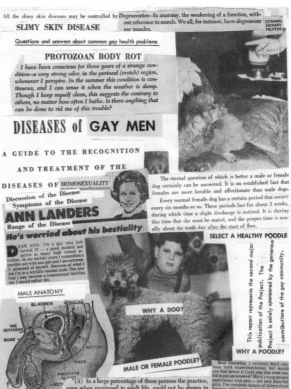

All the slimy skin diseases may be controlled by

## SLIMY SKIN DISEASE

*Degeneration*—In anatomy, the weakening of a function, without reference to morals. We all, for instance, have *degenerate* ear muscles.

EXTERNAL URINARY MEATUS

Questions and answers about common gay health problems

### PROTOZOAN BODY ROT

*I have been conscious for three years of a strange condition—a very strong odor, in the perineal (crotch) region, whenever I perspire. In the summer this condition is continuous, and I can sense it when the weather is damp. Though I keep myself clean, this suggests the contrary to others, no matter how often I bathe. Is there anything that can be done to rid me of this trouble?*

# DISEASES of GAY MEN

## A GUIDE TO THE RECOGNITION

## AND TREATMENT OF THE

## DISEASES OF HOMOSEXUALITY

Discussion of the Disease

Symptoms of the Disease

## ANN LANDERS

Range of the Disease

### He's worried about his bestiality

DEAR ANN: I'm a gay who just turned 17 — a good student and active in many high school activities. In my earlier years I committed a terrible act with our pet and I am extremely ashamed of myself. Because of what I did I'm in a terrible mental state. The fear that I may become a homosexual terrifies me. I would rather die.

The eternal question of which is better a male or female dog certainly can be answered. It is an established fact that females are more lovable and affectionate than male dogs.

Every normal female dog has a certain period that occurs every six months or so. These periods last for about 3 weeks, during which time a slight discharge is noticed. It is during this time that she must be mated, and the proper time is usually about the tenth day after the start of flow.

SELECT A HEALTHY POODLE

This report represents the second major publication of the Project. The Project is solely sponsored by the generous contributions of the gay community.

### MALE ANATOMY

BLADDER  VESICLES

VAS DEFERENS

BONE

RECTUM

ANUS

PROSTATE GLAND

PENIS  URETHRA

SCROTUM  TESTIS

(3) In a large percentage of these persons the practice, even when continued in adult life, could not be shown to produce ill effects.

WHY A DOG?

MALE OR FEMALE POODLE?

WHY A POODLE?

Dear Counting: I certainly don't condone such experimentation, but would you feel better if I told you that what you did is not uncommon? Many young people experiment with pets — not only boys but girls. I've received dozens of letters from females who want to know if they can become pregnant by a dog. (The answer is no.)

---

| SIGHT 1 | SOUND 2 | SMELL 3 | TASTE 4 | TOUCH 5 | CONCEPT 6 |
|---|---|---|---|---|---|

Central Arkansas, well hung s 160 lbs. 6'. looking for hot acti studs. Photo for fast reply.

CLARINET

COMPOSITE

INFLUENCE

HOMERUN

LESS

RELAY

SEAL

SPECTACLE

TABLESPOON

ROUGH

MITTEN

EXCHANGE

DUMMY

DEMAND

HONEYCOMB

QUIT

NAPKIN

SIDEWAYS

SIMILITUDE

SLEEP

HOLLOW

FOUNDATION

Modern English

**INTERVIEWER:** What do cutups offer the reader that conventional narrative doesn't?

**BURROUGHS:** Any narrative passage or any passage, say, of poetic images is subject to any number of variations, all of which may be interesting and valid in their own right. A page of Rimbaud cut up and rearranged will give you quite new images. Rimbaud images —real Rimbaud images—but new ones.

**INTERVIEWER:** You deplore the accumulation of images and at the same time you seem to be looking for new ones.

**BURROUGHS:** Yes, it's part of the paradox of anyone who is working with word and image, and after all, that is what a writer is still doing. Painter too. Cutups establish new connections between images, and one's range of vision consequently expands.

**INTERVIEWER:** Instead of going to the trouble of working with scissors and all those pieces of paper, couldn't you obtain the same effect by simply free-associating at the typewriter?

**BURROUGHS:** One's mind can't cover it that way. Now, for example, if I wanted to make a cutup of this [*picking up a copy of the Nation*], there are many ways I could do it. I could read cross-column; I could say: "Today's men's nerves surround us. Each technological extension gone outside is electrical involves an act of collective environment. The human nervous environment system itself can be reprogrammed with all its private and social values because it is content. He programs logically as readily as any radio set is swallowed by the new environment. The sensory order." You find it often makes quite as much sense as the original. You learn to leave out words and to make connections. [*Gesturing*] Suppose I should cut this down the middle here, and put this up here. Your mind simply could not manage it. It's like trying to keep so many chess moves in mind, you just couldn't do it. The mental mechanisms of repression and selection are also operating against you.

Grades 1-2

Uses drawings to express his ideas

Writes picture stories

Content

Places value on his own ideas in cooperative or individual composition

Puts ideas into words in dictating to the teacher or in writing under teacher guidance titles, captions, stories, verse

Begins to give reactions to and opinions of experiences, both real and vicarious

Begins to dictate and write ideas in sequence

Begins to use judgment as to what is appropriate to include in various types of letters and notes

Listening can be purposeful, critical, selective, and creative. Listening span varies with the person, the situation in which he is, the hour of the day, his reasons for listening, and the nature of the speaker's presentation. *Passive listening* often means no more than the awareness of noise. Other thoughts occupy the mind. In *partially attentive listening*, the listener vaguely realizes what is said by attending to a key word, a word said emphatically, or a change of tempo. He tunes in and out as it went, to suit his purposes. In *active listening*, the listener follows carefully, evaluates, weighs evidence, and draws conclusions on which to act.

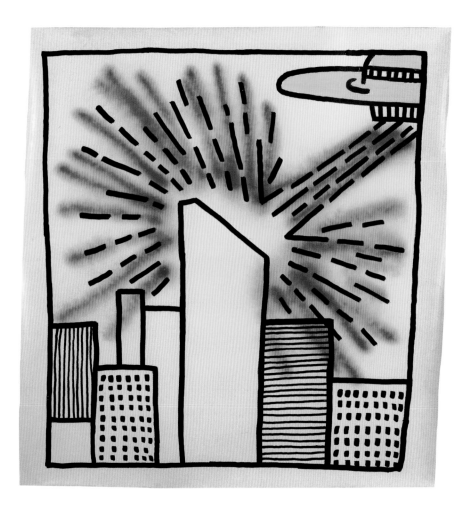

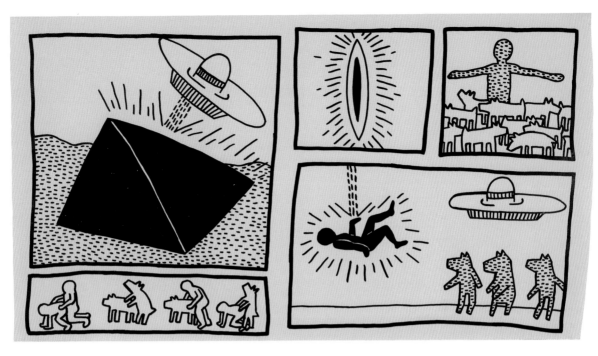

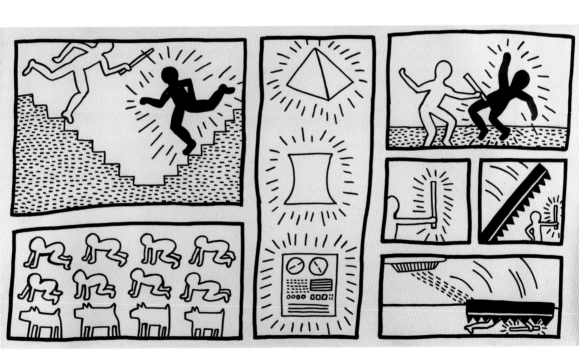

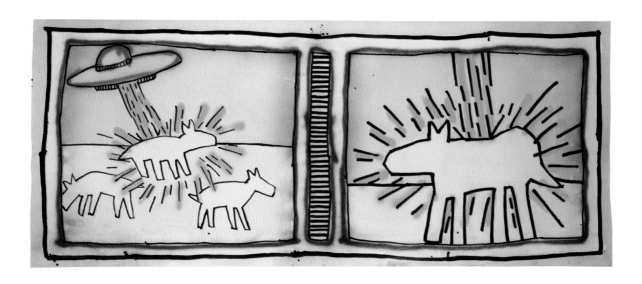

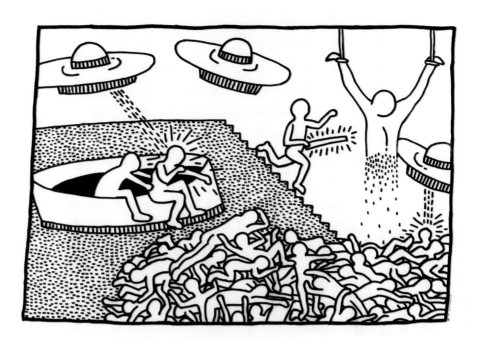

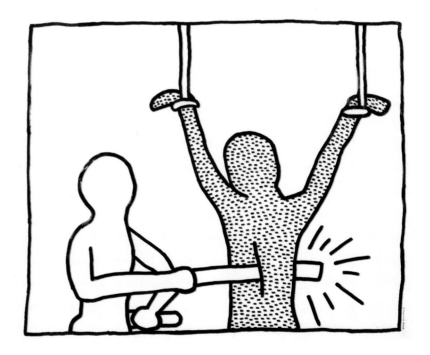

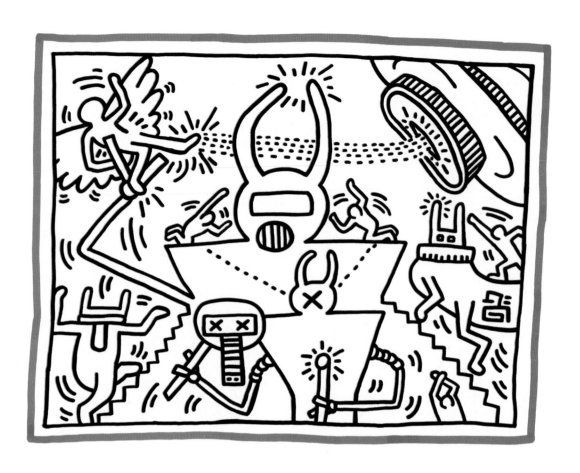

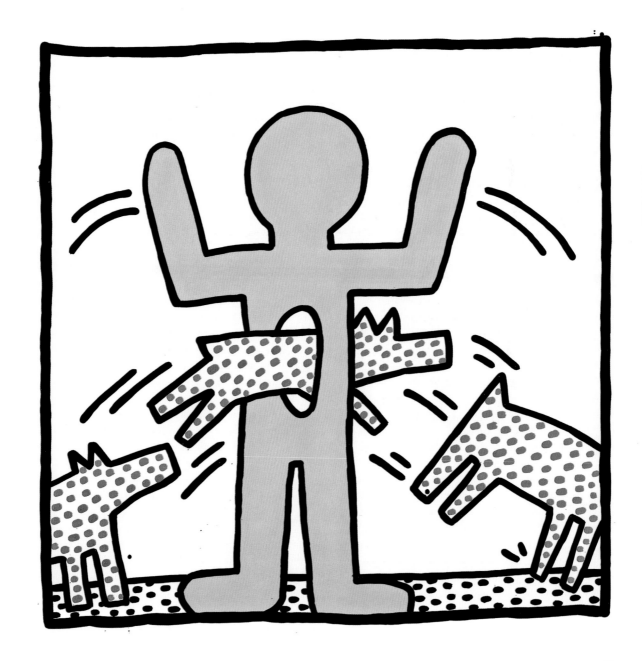

31

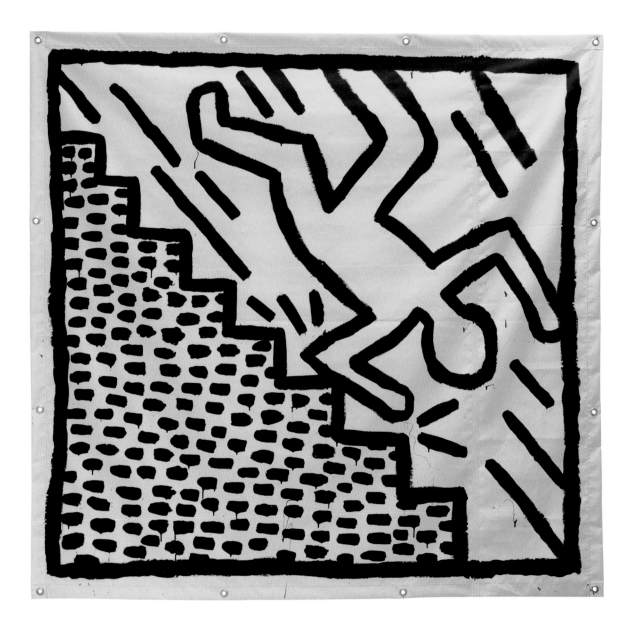

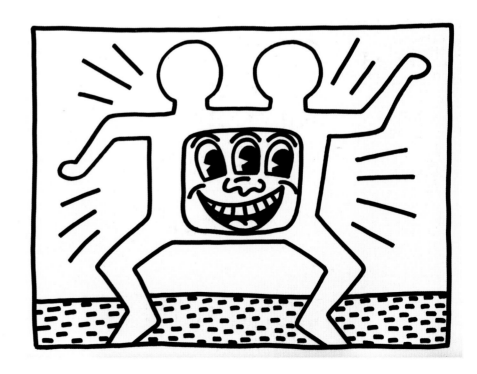

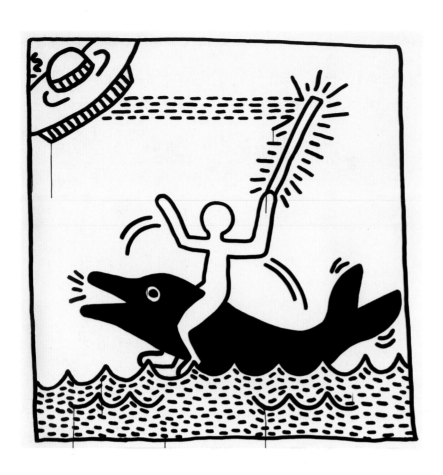

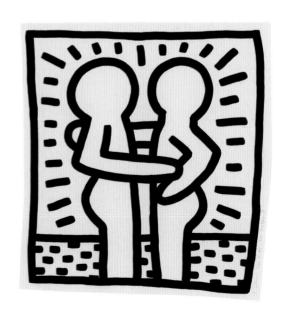

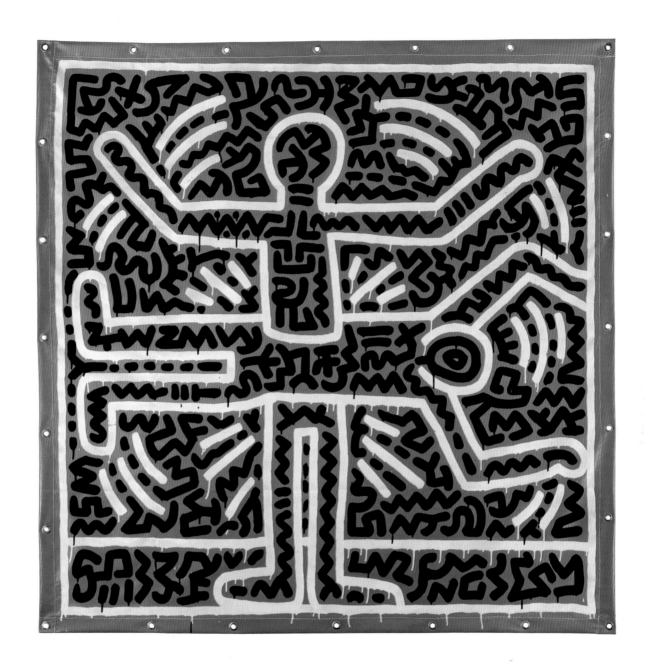

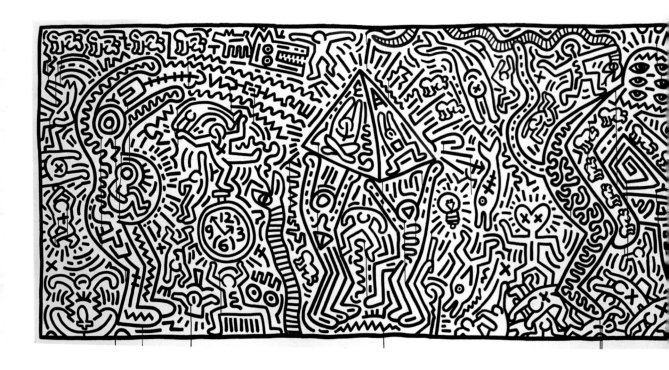

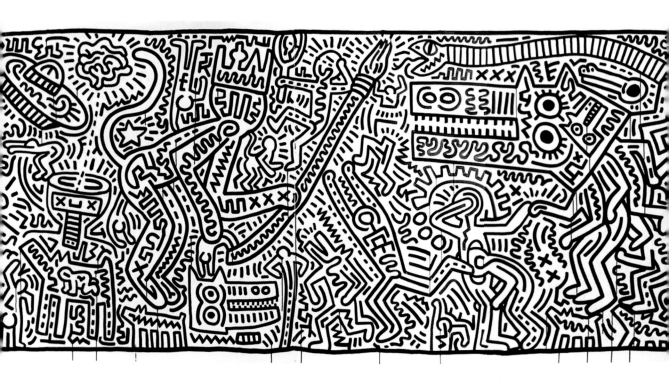

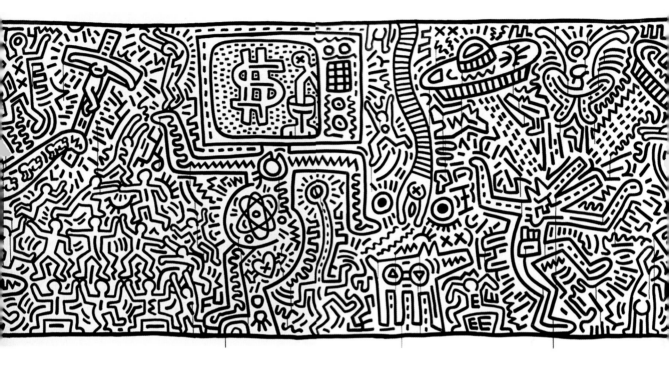

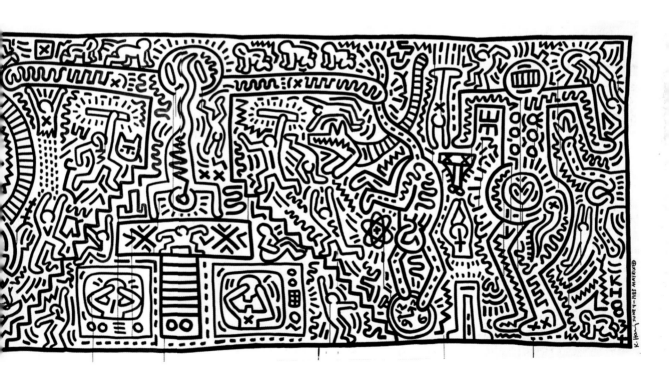

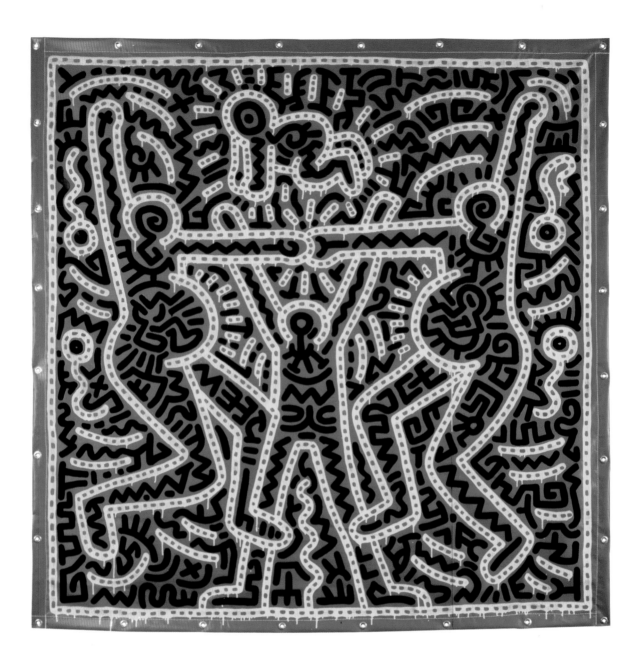

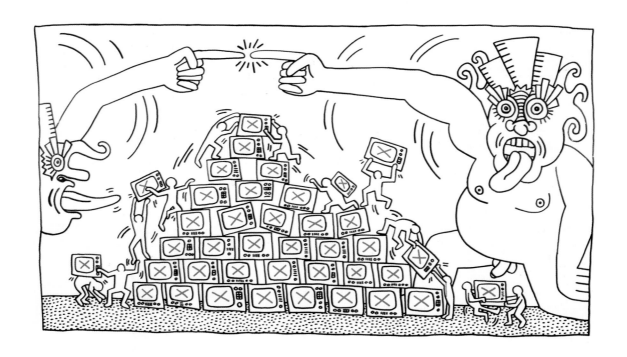

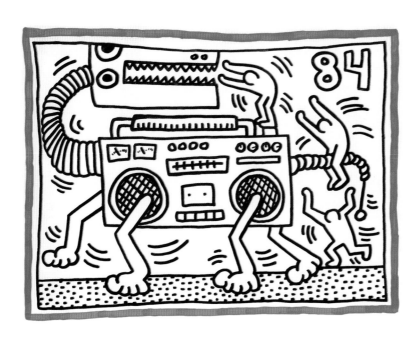

43

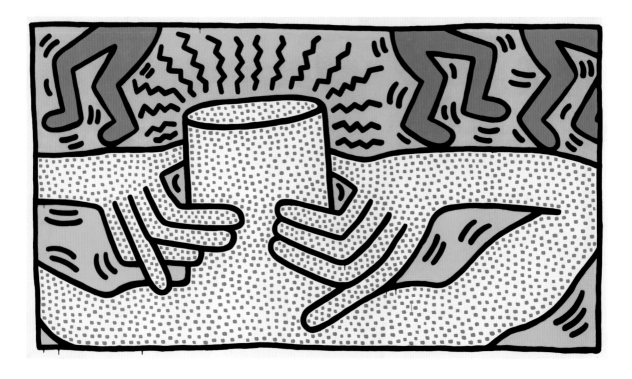

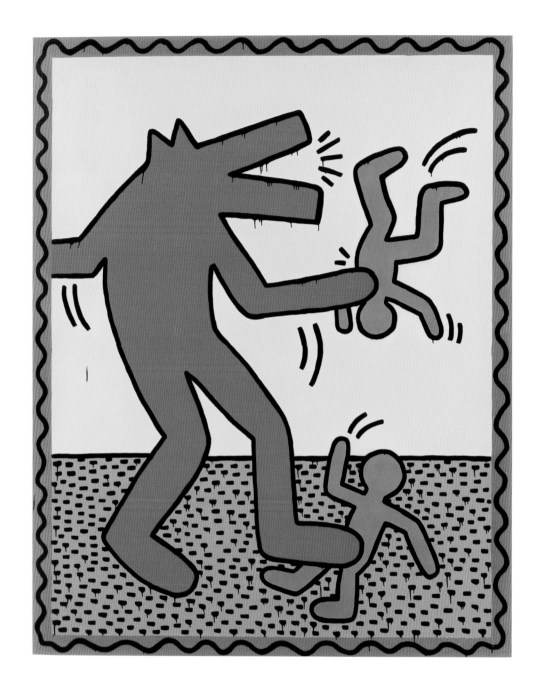

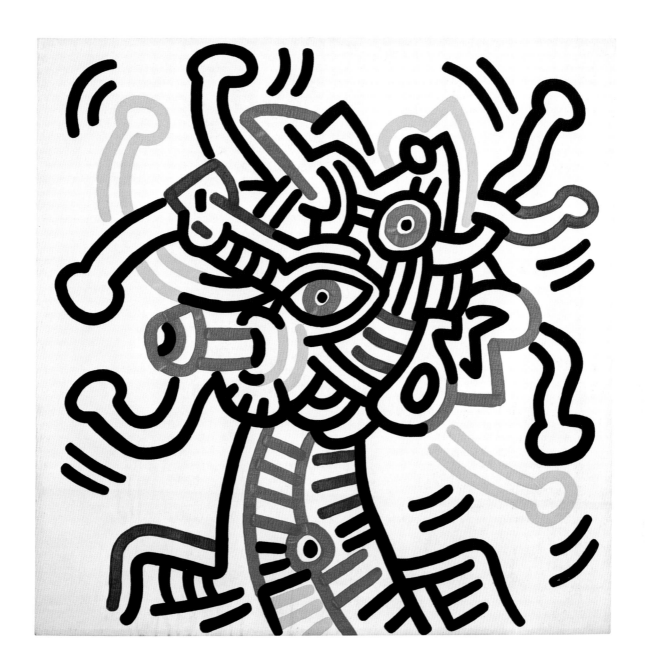

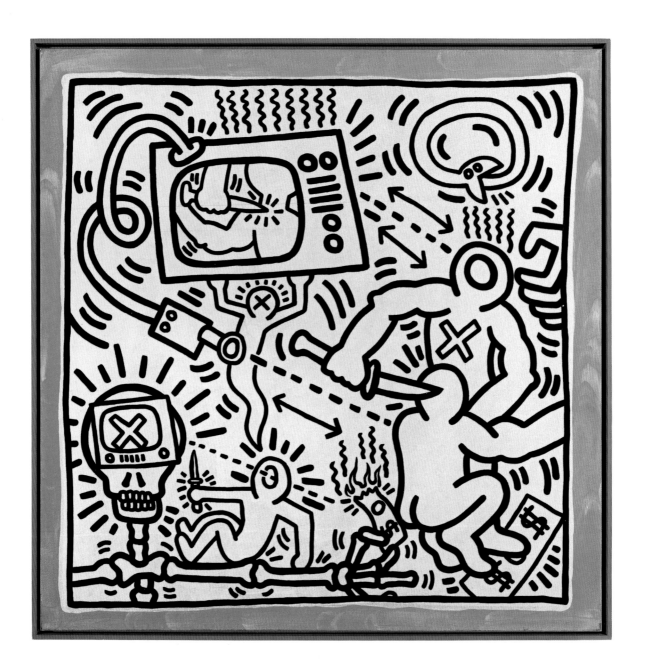

[p.21]
Tseng Kwong Chi,
*Keith Haring with
electronic billboard,
Times Square, New York*
1982, Muna Tseng
Dance Projects, Inc

[p.22]
*No Sin, Art Sin,
No Fat, Fat Sin* c.1979,
Xerox collage,
Four parts, each:
27.9 × 21.6, Collection
of the Keith Haring
Foundation

[p.23, top]
*Untitled (Diseases
of Gay Men)* 1979,
Ink and collage
on paper, 27.9 × 21.6,
Collection of
the Keith Haring
Foundation

[p.23, bottom]
*Untitled (Sight Sound
Smell Taste Touch
Concept)* c.1979,
Ink and collage on
paper, 27.9 × 21.6,
Collection of
the Keith Haring
Foundation

[p.24]
*Untitled (Spaceship
with Ray)* 1980, Ink,
enamel and spray paint
on paper, 121.9 × 115.6,
Benatar Collection,
courtesy Skarstedt
Gallery, New York/
London

[p.25, top]
*Untitled (Drawings for
Fashion Moda)* 1980,
Ink on poster board,
121.9 × 230.2,
Collection Alona Kagan

[p.25, bottom]
*Untitled* 1980,
Ink on poster board,
121.9 × 230.2, Collection
of the Keith Haring
Foundation

[p.26]
*Untitled* 1980, Acrylic
paint, enamel paint and
sumi ink on paper,
121.9 × 294.6, Private
collection, courtesy
The Heller Group

[p.27, top]
*Untitled* 1981,
Sumi ink on vellum,
105.4 × 156.2,
Collection Alona Kagan

[p.27, bottom]
*Untitled* 1981,
Sumi ink on vellum,
105.4 × 132.1, Collection
Alona Kagan

[p.28, top]
*Untitled* 1981, Sumi ink
on paper, 95.3 × 125.7,
Private collection,
courtesy
Martin Lawrence
Galleries

[p.28, bottom]
*Untitled* July 1980
Ink, acrylic paint and
spray paint on paper,
121.9 × 171.5,
Collection of
the Keith Haring
Foundation

[p.29]
*Untitled (Three Men
Die in Rescue Attempt Six
Months after John
Lennon's Death)* 1981,
Ink and acrylic paint on
paper, 97 × 127, Private
collection, courtesy of
Tony Shafrazi Gallery

[p.30]
*Untitled* 1983,
Ink and gouache on
paper, 97.2 × 127,
Collection Julie and
Edward J. Minskoff

[p.31]
*Untitled* 1982,
Baked enamel on
steel, 109.2 × 109.2,
Collection of
Larry Warsh

[p.32]
*Untitled* 1981,
Vinyl paint on vinyl
tarpaulin, 185 × 193,
Private collection

[p.33, top]
*Untitled* 1982,
Acrylic paint on
canvas, 30 × 30,
Collection Vasilisa
Sukhova

[p.33, bottom]
*Untitled* 1982,
Ink on paper,
76.2 × 101.6,
Private collection,
courtesy
Martin Lawrence
Galleries

[p.34, top]
*Untitled* 1982,
Sumi ink on paper,
192.1 × 192.1,
Courtesy Laurent Strouk

[p.34, bottom]
*Untitled* 1983,
Sumi ink on paper,
50 × 50, BvB Collection,
Geneva

[p.35]
*Untitled* 1983,
Acrylic paint
on vinyl tarpaulin,
186 × 188, Courtesy
Laurent Strouk

[p.36–37]
*The Matrix* 1983,
Sumi ink on paper,
182.9 × 1521.5,
Collection of
the Keith Haring
Foundation

[p.38]
*Untitled* 1983,
Vinyl paint on vinyl
tarpaulin,
213.4 × 213.4, Courtesy
Laurent Strouk

[p.39]
*Untitled* 1982,
Baked enamel on steel,
109.2 × 109.2 × 5,
Collection
Strauss Zelnick and
Wendy Belzberg

[p.40–1]
*Untitled* 1983,
Acrylic paint on leather,
134.6 × 294.6,
Private collection

[p.42]
*Untitled* 1983,
Acrylic paint on canvas,
160 × 160, Courtesy
Laurent Strouk

[p.43, top]
*Untitled* 1983,
Sumi ink on paper,
182.9 × 335.3,
Collection of
the Keith Haring
Foundation

[p.43, bottom]
*Untitled* 1984,
Sumi ink on paper,
96 × 115,
Private collection,
Hamburg

[p.44, top]
*Untitled* 1982,
Day-glo paint on wood,
81.2 × 63.5, Collection
of Larry Warsh

[p.44, bottom]
*Untitled* 1984,
Acrylic paint, enamel
paint and Day-glo paint
on wood, 174 × 63 × 3,
Private collection

[p.45]
*Untitled* 1982,
Enamel paint and
Day-glo paint on metal,
229.8 × 183.8,
Collection of
the Keith Haring
Foundation

[p.46, top]
*Untitled* 1987–9,
Gouache, sumi ink
and printed papers
on paper, 62.2 × 75,
Private collection

[p.46, bottom]
*Untitled* 1987–9,
Gouache, sumi ink
and printed papers
on paper, 62.2 × 75,
Private collection

[p.47]
*Untitled* 1987,
Acrylic paint on canvas,
100 × 100, Private
collection, Belgium

[p.48]
*Untitled* 1985,
Acrylic paint on canvas,
152.5 × 152.5,
Van de Weghe Fine Art,
New York

# Keith Haring and the City as a Medium for Self-Realisation

by Hans-Jürgen Lechtreck

*I wanted intensity for my art and I wanted intensity for my life.*[1]

On learning of Andy Warhol's death in 1987, Keith Haring wrote, in a letter of condolence to Paige Powell, the associate publisher of *Interview* magazine, 'It is difficult to imagine New York City without him.'[2] Something of the writer's own ambition can be seen in this expression of high regard for the dead artist. At the same time, a reversal in the sentence presents us with another viewpoint for understanding both Warhol's and Haring's life and work: it is difficult to imagine these artists without New York City. Haring, who was born in Reading, Pennsylvania, in 1958 and raised in the nearby, small provincial town of Kutztown, often described Warhol's pop aesthetic and self-conception as an artist as an important inspiration and precondition for his own work. In his twelve years there, the big city became the place where he could live openly as a homosexual, realise himself as an artist and eventually make a career: 'Obviously, the only place to go was New York. It was the only place where I would find the intensity I needed and wanted. I wanted intensity for my art and I wanted intensity for my life.'[3]

After moving from Pittsburgh to New York City in 1978, the twenty-year-old Haring soon realised that the city opened up new opportunities for him to unite his artistic interests as part of a working method that had an effect extending beyond the gallery and a public that was traditionally interested in art. Haring's preoccupations at that time can clearly be seen from diary entries concerning his studio exhibitions in the Pittsbugh Arts

1   *Keith Haring Journals*, New York 1996, p.11: 'I believe we have reached a point where there can be no more group mentality, no more movements, no more shared ideals. It is a time for self-realization.'
2   John Gruen, *Keith Haring: The Authorized Biography*, New York 1991, p.169.
3   Gruen 1991, p.32.
4   *Keith Haring Journals*, 1996, p.25ff.
5   Gruen 1991, p.36f. See also Kenny Scharf, quoted in Gruen 1991, p.56f: 'If he was in a student show, he'd make hundreds of Xeroxes announcing it and hand it out to everybody and put it everywhere.'

and Crafts Centre (now the Pittsburgh Center for the Arts) and at the School of Visual Arts (SVA) in New York: developing a reduced style of drawing, based on recurring and combinable elements, that would function as a pictorial language or visual alphabet; interlacing his own and found images and texts and various materials and media, while including the entire room and its contents within the artwork environments. Haring would further energise the presentation through movement and the activation of the audience in the production of meaning.[4] Haring's declared aim was to make his works accessible to as many viewers as possible, in the sense of making them both visible and understandable.

Consequently, after 1980, Haring turned ever more frequently to city spaces and structures, as well as various social and cultural city environments, in order to realise his art. Artistic actions and personal interests were also combined in such a way that Haring frequently appears as subject and object at the same time. Like the subway drawings that initially made him famous, his early collages and Xerox works were both commentaries on topical themes in the city and declarations or advertisements on his own behalf.[5] This was true of the works on the subject of (homo)sexuality in particular: 'I was also

Tseng Kwong Chi, *Haring Drawing in New York Subway* c.1983–5, Silver gelatin print, 20.3 × 25.4, Muna Tseng Dance Projects, Inc

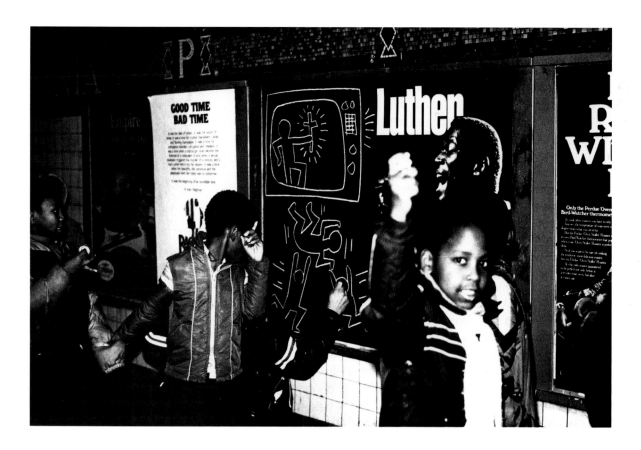

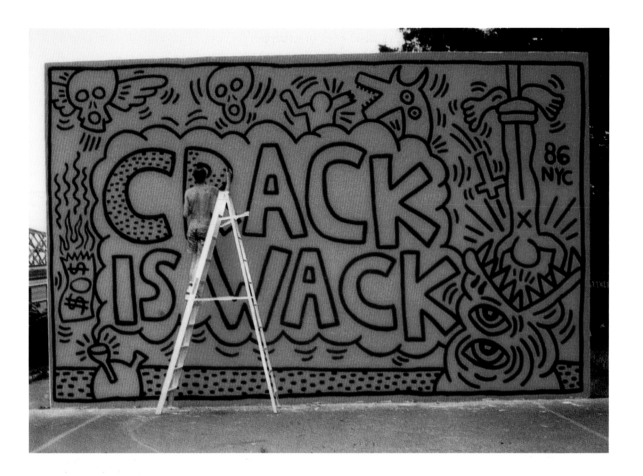

kind of combining what was happening at night and what
was happening at school, which meant that the subject
matter of many of my drawings was completely phallic.
It was a way of asserting my sexuality and forcing other
people to deal with it.'[6] Haring was always primarily
concerned with the possibilities of a kind of communication
that could assert itself in the visual culture of the
(post-) modern city, with its increasingly complex mixture
of analogue and digital symbols, images and texts, and
with conveying alternative content and meanings
with such communication.[7]

This was one reason for his interest in graffiti art.
However, unlike graffiti writers and artists, some of
whom he got to know personally and invited to collaborate
with him, Haring wanted to make his art effective in
contexts expanding beyond city boundaries, as well as
crossing social and cultural borders. Motivated by this
desire, his drawings in public spaces were clearly different
from the spray-painted tags and pieces that were intended
to demonstrate a desire for self-assertion and a claim
to power, and were only understood within the graffiti
scene itself (and by those with knowledge of the local

Keith Haring
painting
*Crack is Wack* mural,
New York 1986

codes).[8] His drawings were motifs made up of simple lines – immediately recognisable and easy to remember – confronting viewers on precisely-defined surfaces, often already familiar as supports for images and text. With the subway drawings, executed in chalk on blank advertising spaces covered with black paper in New York subway stations, Haring himself also had limited control over how long the works would remain visible. These were not so much aggressive disturbances or examples of overwriting, as games played with empty or unused spaces that were temporarily available, and aimed at the New York City Transit Police, and pedestrians and passengers as well: 'When we spot the Radiant Baby or Barking Dog, we not only have seen them before and know we will see them again, soon, we also know that tens of thousands of our fellows will see them as well.'[9]

Haring was also consciously aware of artistic approaches that since the 1960s had been critical of traditional art institutions and structures, including the staging of Happenings and the actions of the Fluxus movement, as well as the work of some of the artists who were active in the streets of New York City from the late 1970s, such as Barbara Kruger and Jenny Holzer in particular. Shortly after Holzer initiated her ongoing 'Truisms' series, consisting of text-based aphorisms and clichés inscribed into the texture of the city through posters, stickers and t-shirts, Haring adopted a similar subversive strategy, taping fragments of his drawings and paintings on paper to lamp posts and newsstands. In his diaries he mentioned several times the suitability of various media and styles for achieving 'higher levels of communication' – being 'more direct, more involved' – and criticised the inaccessibility and incomprehensibility of the art establishment.[10] He was intensely preoccupied with where and how he could exhibit his art and, for him, this question had the same urgency as the development of his style of drawing: 'However, the "art experience" is as dependent if not more dependent on context, concept, viewing situation, and the personal preconceptions and miscellaneous knowledge of the viewer's context, than one of those formal qualities.'[11]

Haring found answers in the urban area of New York City, on which the changing status of the economy had left its mark. In the 1980s, the city government, property speculators and companies in the finance and service sectors were refurbishing and expanding the city in a postmodern style and the population was experiencing a new wave of internationalisation as a result of rapidly increasing immigration from Asia, Latin America and the Caribbean.[12] The *Times Square Show*, held in summer 1980

6   Gruen 1991, p.39. See also David Sheff, 'Keith Haring: Just Say Know', *Rolling Stone*, no.558, 10 August 1989, pp.58–66, 102.
7   Gruen 1991, p.56 and throughout. See also Claus Dreyer, 'Stadt als Text, als Massenmedium oder als Event? Wandlungen in den Lesarten des Urbanen aus semiotischer Sicht', in Dieter Hassenpflug, Nico Giersig and Bernhard Stratmann (eds.), *Reading the City: Developing Urban Hermeneutics/Stadt lesen: Beiträge zu einer urbanen Hermeneutik*, Weimar 2011, pp.59–67.
8   Ulrich Blanché, 'Keith Haring – A Street Artist?', in Pedro Soares Neves (ed.), *Street Art & Urban Creativity Scientific Journal: Center Peripher: Practice*, vol.2, no. 1, 2016, pp.6–18.
9   Henry Geldzahler, 'Introduction', in *Art in Transit: Subway Drawings by Keith Haring*, New York 1984, unpaginated.
10  *Keith Haring Journals*, 1996, p.15. See also Geldzahler, ibid., 1984, p.26 and throughout.
11  *Keith Haring Journals*, 1996, p.60. See also ibid., p.7: 'There are so many different ways to experience the phenomena of the city. A given situation can have an unlimited number of different effects on a person's thoughts, depending on the state of mind and attitude. Something that affects me today will not necessarily affect me tomorrow.'

12 See also Arnold Voß, 'New York verändert nicht nur sein Gesicht – Die sozialräumliche Entwicklung der Weltmetropole zwischen den Jahren von 1970 bis 1990', in Ursula von Petz and Klaus M. Schmals (eds.), *Metropole, Weltstadt, Global City: neue Formen der Urbanisierung*, Dortmund 1992, pp.43–70, and Remco van Capelleveen, 'Die Internationalisierung der Stadt New York', *Forschungsjournal Neue Soziale Bewegungen*, year 3 (1990), no.4, pp.66–72.

13 Jeffrey Deitch, 'Report from Times Square', *Art in America* (September 1980), no.7, p.59.

14 Ibid. See also Lucy R. Lippard, 'Sex and Death and Shock and Schlock: A Long Review of "The Times Square Show"', in Howard Risatti (ed.), *Postmodern Perspectives: Issues in Contemporary Art*, Englewood Cliffs, NJ 1990, pp.78–87.

15 Paul Donker Duyvis, 'Every Station Is My Gallery: Interview with Keith Haring', in *Keith Haring: Paintings, Drawings and a Velum*, exh. cat., Stedelijk Museum, Amsterdam 1986, pp.45–7, here p.45.

16 *Keith Haring Journals*, 1996, p.28. See also Jean Baudrillard, *Kool Killer oder Der Aufstand der Zeichen*, Berlin 1978, p.24ff.

17 Gruen 1991, pp.66f. (Fab Five Fred), 80 (LA II), 118f. (Keith Haring) and throughout.

18 Jörg Heiser, 'Kontextwechsel zwischen Kunst und Popmusik?', *Doppelleben: Kunst und Popmusik*, Hamburg 2015, pp.27–42:

19 Gruen 1991, p.62.

20 Ibid., p.85f.

in an empty four-storey building near Times Square, was a key experience for Haring. The exhibition, initiated by the artists' group Collaborative Projects, in which over 100 artists from the underground and New Wave scene took part (including Jean-Michel Basquiat, Jenny Holzer and Kiki Smith, as well as Haring), brought together works in various media and styles. It filled the rooms on all floors, including the basement, from floor to ceiling. Painting, photography, object art, performance, and graffiti combined to create an environment that bore no relation to the familiar ways of presenting art in galleries and museums. Times Square, described at the time as 'New York's behavioral sink, the place where people go to do all the things that they can't do at home',[13] not only gave its name to the show but was also the most important reference point in terms of content: 'By and large, the art used imagery that anyone who walks the streets of New York would find familiar ... There was plenty of sex and violence too, of course. And ... much of the art was politically charged.'[14] The *Times Square Show* made the art establishment aware of the underground and New Wave scene, which had previously received little attention, and was also a demonstration against the way long-established residents of Manhattan – including many of the exhibiting artists – were increasingly being driven out by the renovation and building boom in the city.

In an act of self-empowerment – 'Do it yourself and make it' – from that time on, Haring used the city as a studio and exhibition space, always endeavouring to make his art both react against and coalesce with the established forms of communication.[15] As mentioned above, Haring's subway drawings were created on blank advertising spaces in subway stations, where they were quickly spotted by passengers and pedestrians as they hurried past, and he liked to place his early, illegal wall paintings on walls in very busy streets, where their function was similar to that of billboards. His strategy was to work with the city's media forms rather than against them, in order to prise open their obvious relationship between sender and receiver: 'I am constantly being bombarded with influences from my environment. I only wish to throw some of them back.'[16] His artistic actions offered opportunities for official, one-sided, urban mass communication, and its media and signage systems, to be used in a different way and for other purposes. His animated drawings for the Spectacolor billboard at Times Square (1982) were probably the most impressive example of this.

In other urban contexts, Haring collaborated with artists, dancers, musicians, and others who already

had a presence or profile, in order to reach different audiences. An episode recounted by the graffiti artist Fab Five Freddy (Fred Brathwaite) clearly shows how quickly Haring made the necessary contacts. One night the two of them found a group of youngsters spraying graffiti in a school yard. The very next day Haring went back there to carry out some artistic activity of his own on one of the walls that was still blank, as well as making the acquaintance of the then-fourteen-year-old graffiti writer LA II (Angel Ortiz). Haring collaborated with LA II on Haring's own first gallery exhibition, in 1982, and on the decor for his 'Party of Life' in the Paradise Garage disco in 1984,[17] as well as various other projects.

These collaborations provided Haring with a significant new impetus for his own artistic work (he himself relates them to dance, performance, video art, music and literature), but, most importantly, they opened up new opportunities and sites for action, raising awareness of Haring as an artist in very different parts of the city and eventually attracting the attention of the art establishment as well.[18] Between 1978 and 1981, in the nightlife spots Club 57 and the Mudd Club, he organised a series of exhibitions of his own works and those of other artists, including graffiti writers, linking up with the staff and customers of these clubs for live, multi-art experiences. For Haring and other leading participants in the underground and New Wave movements, these exhibitions were opportunities to meet and exchange views on topics including their art, music, dance styles and fashion.[19]

In 1982, Haring took advantage of these experiences and contacts when gallery owner Tony Shafrazi offered him a solo exhibition. He covered the walls from floor to ceiling with wall drawings and paintings on vinyl tarpaulins (on the ground floor) and pictures and objects painted in fluorescent colours, as part of a black-light installation (in the basement). His ability to draw rapidly on large surfaces and his knowledge of setting up exhibitions were mutually complementary. However, the crucial element in the exhibition's success with the public and in the media was the opening, for which Haring mobilised widely differing social and cultural groups of city society. 'Everybody I knew from the club scene, the art scene, and the graffiti scene was there. It was this big mix-match of people, which had really never existed at a gallery opening before.'[20]

Haring's resolution to merge his artistic work with his private life in New York was one of the determining features of his life and one of its most important sources of energy. For him, the places he had got to know as a student, a pedestrian and a traveller on the subway, as

21 *Keith Haring Journals*, 1996, p.45.
Similarly: 'It's July 4 [1979] on
the top of the Empire State Building
after reading an ART SIN BOY
mimeograph at Club 57 watching
fireworks and thinking about
a smile exchanged on the street
and nothing but a second glance
and lots of dreaming.' Ibid., p.70.
22 Gruen 1991, p.111.
23 Ibid., p.118.
24 Ibid., pp.72, 86, 119, 142
and throughout.

a clubber and a part of the homosexual subculture, and where he eventually became active as an artist, often elicited very personal experiences and emotions. This applies as much to the clubs and discos that Haring regularly visited with his friends and partners as to particular districts, streets or subway stations in Manhattan. 'These fucking boys drive me crazy. This guy in the subway sitting with his legs wide open in front of him – on purpose. Glancing at me and enjoying being looked at ... This energy, sexual energy, may be the single strongest impulse I feel – more than art? (!)'[21] While considering the question of sexual impulse over a compulsion to make art, it can be said that Haring harnessed this energy to live intensely and to produce a prolific body of work.

Haring continued the shift away from the gallery as a conventional space for exhibiting art that had been initiated by previous generations of artists, and created links between urban spaces not usually associated with art and established exhibition sites. Two events he organised just a few months apart provide good examples of how he went about this. In both cases, Haring succeeded in collapsing the distance between the gallery and the discotheque as places for art, at least temporarily. He conceived his second solo exhibition at Tony Shafrazi's gallery in 1983 (once again, in collaboration with LA II and other artists), as an 'active floor-to-ceiling totality'; he turned the gallery basement into a disco space with hip-hop music and as a result, it was visited by break dancers during the entire run of the show.[22] By contrast, on the occasion of his birthday party in May 1984, the 'Party of Life', Haring transformed the rooms of the Paradise Garage into a 'big exhibition', with large-format paintings on lengths of fabric and tarpaulins, as well as various painted objects (on which he and LA II once again used fluorescent paints).[23]

From the very beginning, and before he was discovered by the media establishment, Haring succeeded in using relatively simple means to expand the visibility and effectiveness of his artistic actions and exhibitions beyond the space and time in which they took place. He adapted strategies that were already in use in the visual culture of the city, as with his wall paintings, which he positioned so as to compete with advertising boards. He produced buttons and stickers with motifs from his visual alphabet and handed them out to passers-by who asked him about the subway drawings, and to visitors to his exhibitions. Guests at his Parties of Life were given handkerchiefs, puzzles and T-shirts printed with his drawings.[24] This procedure is reminiscent of the

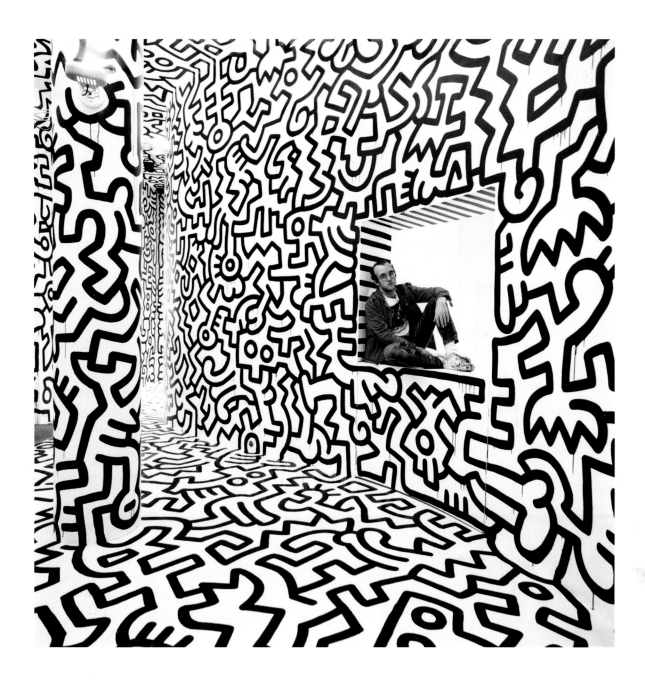

Tseng Kwong Chi,
*Pop-Shop, New York*
1986, Muna Tseng
Dance Projects, Inc

advertising strategies of global companies, whose brand names and logos had gradually infiltrated the urban visual environment via their products and had been worn as fashion statements by purchasers, especially since the 1970s. As a result, Haring's art rapidly became known, though it was not always immediately possible for viewers to make a connection between the work and its creator. Nevertheless, the interplay of anonymity and individuality that was made possible by the big city, and which linked his early work to graffiti and other phenomena of the underground scene, was soon brought to an end by the increasing popularity of the artist himself.

In his hope of actually achieving 'higher levels of communication', Haring made a concerted effort to have his pictorial language infiltrate the social and cultural realm while expanding the contexts for art.[25] In this respect, it is logical that, in the mid-1980s, he began to use motifs such as his radiant baby and barking dog – which might, on their first appearance in the late 1970s, have been considered as the tags of a graffiti writer or an underground artist – as logos, in order to establish his art and its concerns in the visual culture of the metropolis, which was otherwise dominated by corporate design. However, in establishing the Keith Haring 'brand' and founding the Pop Shop in New York City in 1986 (the Tokyo branch opened in 1987), Haring was also reacting to the negative implications of his success in terms of

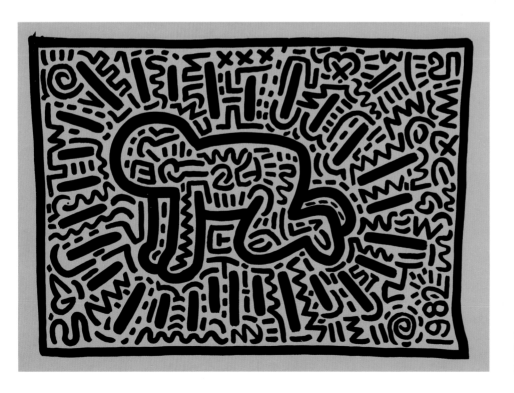

*Untitled* 1982, Sumi ink on paper, 50 × 70, courtesy Laurent Strouk

access to his art. Around 1984, the subway drawings – which had, until then, been the strand of Haring's work that made direct contact with the widest public – began to lose their reach, as they were being removed more and more frequently and stolen just a few hours after they had been completed. 'My work was starting to become more expensive and more popular within the art market. Those prices meant that only people who could afford big art prices could have access to the work. The Pop Shop makes it accessible.'[26] The Pop Shop had a precedent in pop art and concept art from the 1960s. Claes Oldenburg's *The Store* 1961 and The Gift Shop, which was run by artists and had been a constituent part of the 1980 *Times Square Show*, can be cited as direct models.[27] However, another aspect of the context of this enterprise, which continued to operate in New York until 2005 (the Tokyo branch was open for one year only), was that the great success of his idea of a widely accessible art proved damaging for Haring's practice in two ways. Even during his lifetime, he had problems with forgeries (in the sense of faked art works) and product piracy. After his death art historians turned the vast circulation of his motifs against him and assessed his works as merely trifling and pleasant. 'When the Pop Shop opened, the conceptualist's fear was realised: Haring rode the tiger of commerce and was everywhere, global and perfect in his mediated ubiquity.'[28]

However, from today's perspective – with the web increasingly blurring the borders between public and private, high culture and popular culture, art and commerce – the question has arisen of whether this judgement of Haring's art has been based on a misunderstanding. Like theorist Marshall McLuhan, whose writings he had studied carefully, Haring understood the mass media penetration of daily life and its increasing automation as a threat to the human ability to perceive actively and communicate independently.[29] He was therefore convinced that the roles of the human being and the artist in society and culture would have to be redefined. Haring came up with a new definition that fitted himself at the very beginning of his years in New York: 'I gather information, or receive information that comes from other sources. I translate that information through the use of images and objects into a physical form.'[30] Haring's vision, which he realised in his life and his art, was of an (urban) society, in which the individual would be able to communicate – and be understood – across spatial, social and cultural borders. That is why American psychologist and countercultural figure Timothy Leary called Keith Haring the 'twenty-first-century archetypal artist'.[31] **HJL**

25  Ibid., pp.80 (LA II), 125 (Julia Gruen).
26  Sheff 1989, p.64. Haring also wanted the advertising campaigns he designed for Absolut Vodka, Swatch and other brands to be understood in this sense: 'they circulated the work, and the quality was controlled and limited.' Ibid. See also Gruen 1991, p.148.
27  See Lippard 1990, p.79.
28  Bill Arning, 'Haring's Perpetual Power', in Lucy Flint (ed.), *Keith Haring: 1978–1982*, exh. cat. Kunsthalle Wien and Contemporary Arts Center, Cincinnati, OH 2012, pp.222–25, here p.224.
29  *Keith Haring Journals*, 1996, p.17.
30  Ibid., p.35.
31  'What I mean by that, is that the twenty-first century is going to be global – it's going to break down all the national and geographic borders.' Gruen 1991, p.144.

# Art for the Street

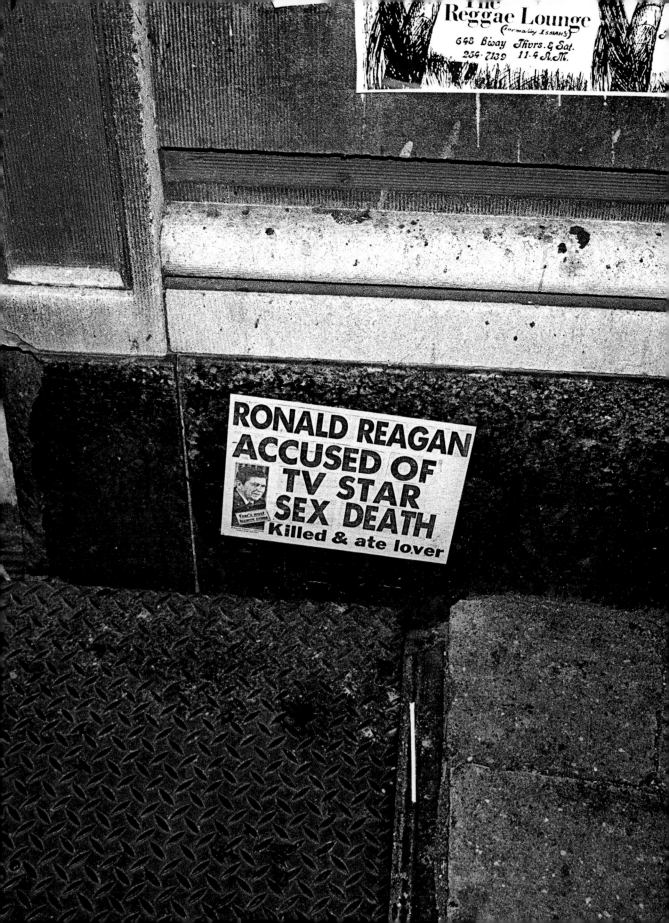

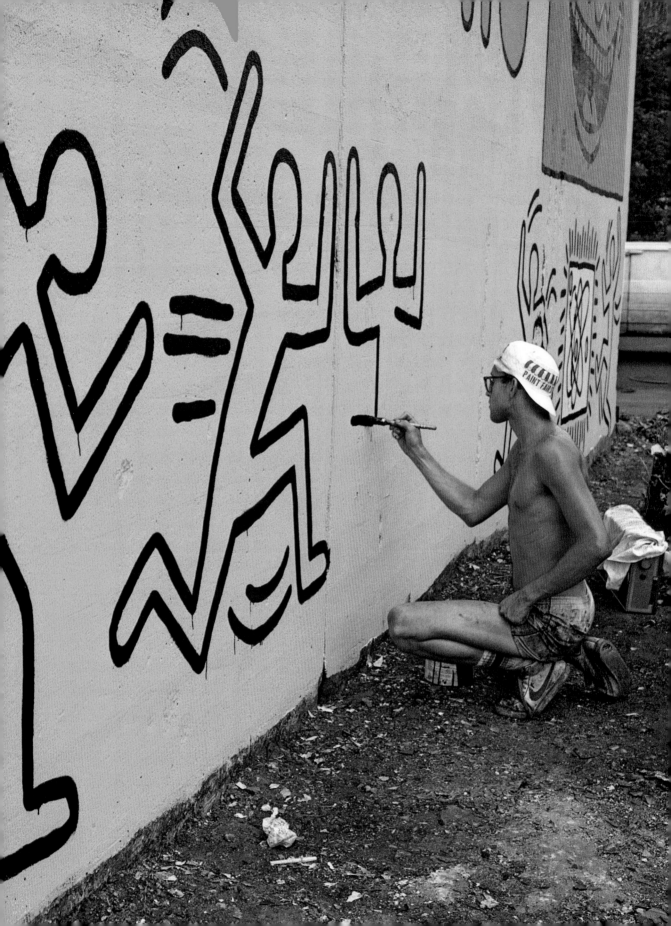

# REAGAN'S DEATH COPS HUNT POPE

'OUR ONLY MISTAKE WAS NOT WINNING'

RONALD REAGAN

# POPE KILLED FOR FREED HOSTAGE

United Press International Photo
*Pope John Paul gives a blessing during a tour of a Salvador slum area before he was mobbed today.*

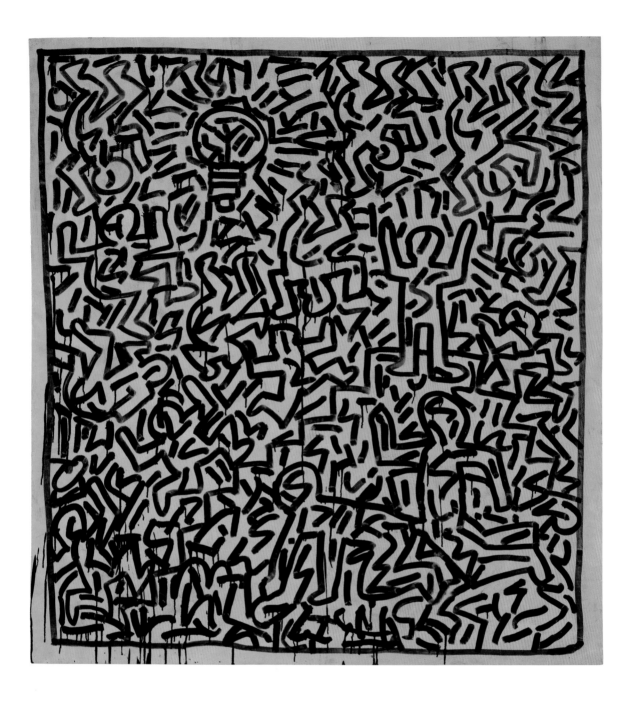

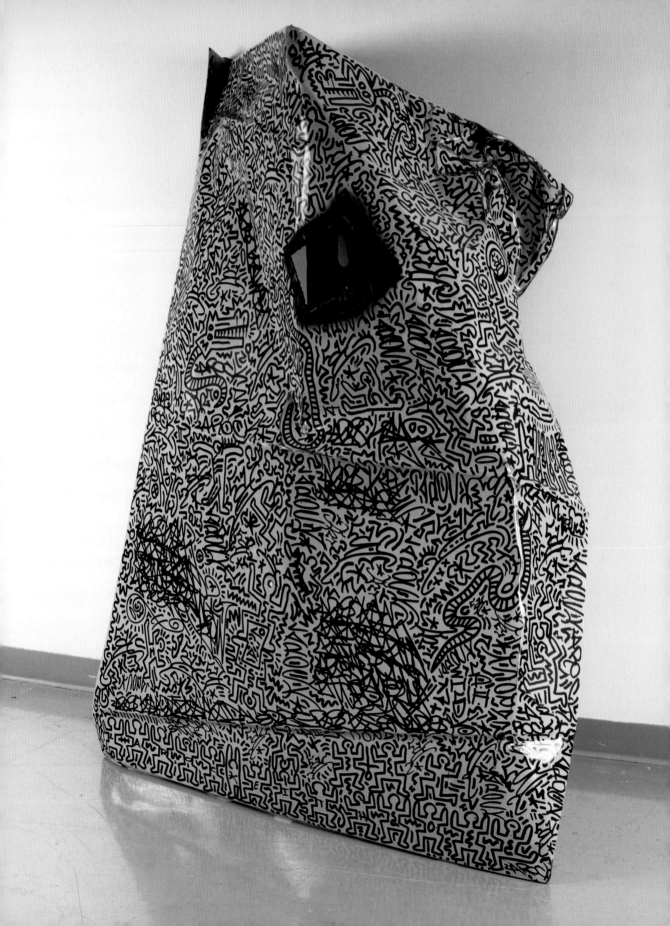

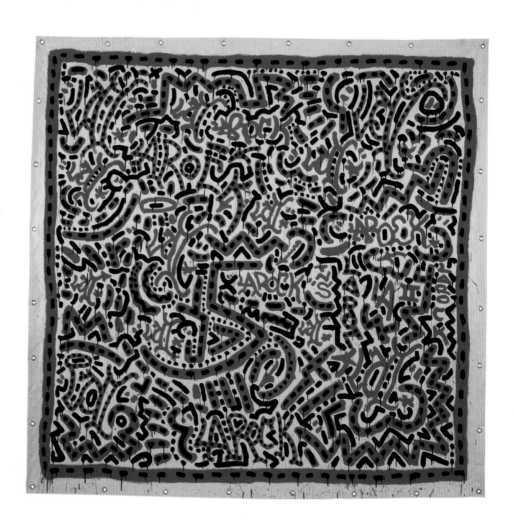

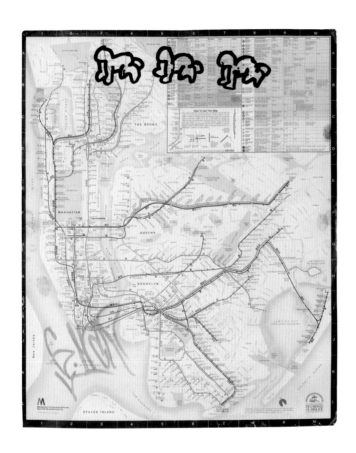

70

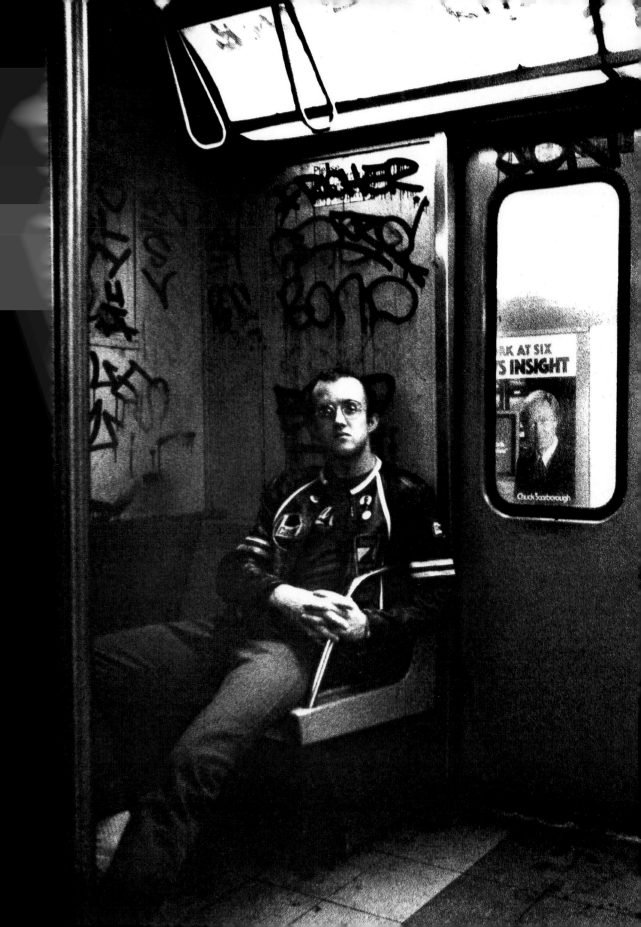

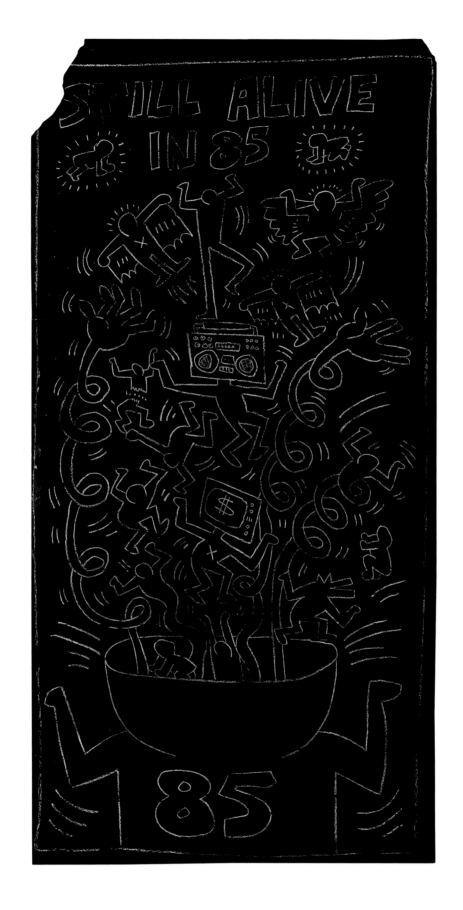

[p.61]
Joseph Szkodzinski,
*Photocopy made from
collage of newspaper
fragments made by
Keith Haring, posted
in New York* 1980

[p.62]
Martha Cooper,
*Keith Haring making
the Houston Street Mural,
New York* 1982

[p.63, top]
*Reagan's Death Cops
Hunt Pope* 1980,
Newspaper fragments
pasted on paper,
21.6 × 27.9, Collection
of the Keith Haring
Foundation

[p.63, bottom]
*Pope Killed for Freed
Hostage* 1980,
Newspaper fragments
pasted on paper,
21.6 × 27.9, Collection
of the Keith Haring
Foundation

[pp.64–5]
*Fragments of paintings,
posted and photographed
by Haring at various
locations in New York
City* c.1980, Mixed
media on paper,
Collection of
the Keith Haring
Foundation

[p.66]
*Untitled* 1981,
Enamel on fibreboard,
121.9 × 121.9,
Private collection

[p.67]
LA II (Angel Ortiz),
Keith Haring, Kenny
Scharf, Jean-Michel
Basquiat, Fab 5 Freddy,
Maxwell, Phaze 2,
Revolt, Poet, 2 Bad,
Peak, Beam, Real,
Tec 2, Ka-Zar #1 and
others, *Art is the Word*
1981, Spray enamel
paint and marker pen
on masonite,
186.7 × 121.9, Collection
Noirmontartproduction,
Paris

[p.68]
Keith Haring and LA II
(Angel Ortiz), *Untitled*
1982, Marker on
taxi hood, 160 × 129.5,
Collection
of Larry Warsh

[p.69]
Keith Haring and
LA II (Angel Ortiz),
*Untitled* 1982,
Tempera on rubber
with metal grommets,
200 × 200, Collection
of the Keith Haring
Foundation

[p.70]
*Untitled (New York
subway map)* 1983,
Sumi ink on printed
paper, in original frame,
72 × 58, Muna Tseng
Dance Projects, Inc

[p.71, left]
*Untitled (Subway
Drawing)* 1983, Chalk
on paper, 220 × 114,
Tony Shafrazi
Gallery New York

[p.71, right]
*Untitled (Subway
Drawing)* 1984, Chalk
on paper, 220 × 115,
Tony Shafrazi Gallery
New York

[pp.72–3]
Tseng Kwong Chi,
*Keith Haring in New York
subway car* c.1983,
Silver gelatin print,
20.3 × 25.4, Muna Tseng
Dance Projects, Inc

[p.74]
*Subway Drawing/Still
Alive in 85* 1985, Chalk
on paper, 205 × 102,
BvB Collection, Geneva

# Keith Haring and Activism

by Paul Dujardin and
Tamar Hemmes

Keith Haring was a child of the 1960s and 70s, growing up against a background of activism and sociopolitical change, in which established institutions were resisted and emancipation fought for in many areas. Haring had an awareness of the issues of the time: the race riots and equal rights demonstrations in cities including Washington and Chicago as well as the assassinations of prominent figures like Martin Luther King Jr and Robert Kennedy in 1968. Between the ages of twelve and sixteen, the artist had a newspaper round, so was familiar with daily headline news during the Vietnam War and the Watergate scandal, each concluding in 1975 and 1974 respectively. Since other key events, such as the first manned moon landing on 20 July 1969, were televised, Haring's generation was more exposed to global affairs than ever before. Born in 1958, he identified as belonging to 'the first generation of the Space Age, born into a world of television technology and instant gratification, a child of the atomic age'.[1]

Raised in a conservative, somewhat religious household, and attending a Protestant church and Sunday school, Haring sought to push the boundaries from a young age. In his early teens, and much to the dismay of his parents, he joined the Jesus Movement, an evangelical Christian movement that had emerged from the counter-culture and the hippie movement in North America in the 1960s and 70s, becoming a so-called 'Jesus Freak' for a short period.[2] These childhood experiences had a profound impact on Haring, and he addressed them through his work with critical hindsight. 'All that stuff stuck in my head', he later declared. 'Even now there are lots of religious images in my work, although they're used in a more cynical way – to show how manipulative those beliefs and images can be.'[3]

Haring's work tackles the most diverse subjects, from the darkest to the lightest, with a cartoon-esque iconography and a style that is both direct and deceptively simple. Inspired by graffiti, his visual vocabulary has its roots in street culture; by using recognisable symbols in his work, he broke down the traditional hierarchies within visual culture, creating openings for something new in both art and society. By combining his iconic, non-gendered

figures with easily understood references to class, race and sexuality, he literally and figuratively devised a radically inclusive platform for the deviant, the taboo, the hidden, the nonconforming, the abnormal.

Upon moving to New York in 1978, Haring was exposed to a variety of subcultures and forms of artistic expression, which greatly affected him. The subversiveness that had been present in embryo since his youth now became his guiding principle. It was a tendency that went further and deeper than what is usually referred to as (political) activism. The neologism 'subversivity' that cultural philosopher and activist Lieven De Cauter introduced into artistic discourse fits perfectly here. He defines the term 'as a disruptive attitude that tries to create openings, possibilities in the "closedness" of a system'.[4] The concept is distinct from 'political subversion'. Radical politics is based on dogmas – on a rigid belief system – and seeks to overthrow the existing order. However, for De Cauter, 'subversivity' involves a (usually temporary) disruption that seeks to create space 'for alterity, for deviance and drifting; a place for taboos, truths who generally must remain hidden, a space for the reality of the abject, for the forbidden, for transgression, the breaking of norms and normality, a space for nonconformity, a space for the undermining of convention and tradition, the canon.'[5] Keith Haring's art is drenched – in terms of theme, form and concept – in 'subversivity' as De Cauter defines that term. 'Subversivity' creates his work, gives it content and its unusual form, and shapes its intention and reception.

The cut-up collages that Haring made in 1980, using the sensationalist visual language of newspaper headlines, exemplify the way in which he employed existing systems to comment on political matters. Bearing proclamations such as 'REAGAN SLAIN BY HERO COP', these works consist of rearranged newspaper headlines and photographs from the *New York Post* and poke fun at the president and the Pope. Rather than treating them as valuable artworks, Haring made photocopies of his collages and took them out into the streets, leaving them for others to encounter and thus transforming them into activist pamphlets. Commenting on and questioning the role of advertising in public debates, Haring's contemporary Barbara Kruger had begun creating similar cut-up works in 1979. Her 1982

1 *Keith Haring Journals*, New York and London 2010, p.101.
2 Natalie E. Philips, 'The Radiant (Christ) Child: Keith Haring and the Jesus Movement', *American Art*, vol.21, no.3, fall 2007, pp.54–5.
3 John Gruen, *Keith Haring: The Authorized Biography*, New York and London 1992, p.16. (First published 1991).
4 Lieven De Cauter, 'Notes on Subversion/Theses on Activism', *Art and Activism in the Age of Globalization*, Reflect no.8, Rotterdam 2011, p.9.
5 Ibid., pp.9–10.

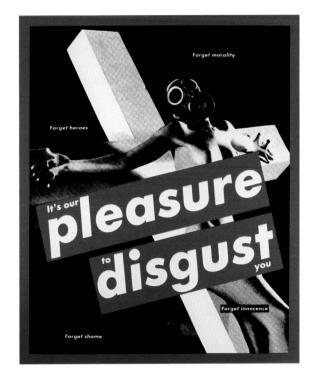

Barbara Kruger, *Untitled (It's our pleasure to disgust you)* 1989, Photographic silkscreen on vinyl, 228.6 × 195.6, Denver Art Museum

work *Untitled (It's Our Pleasure to Disgust You)* depicts
a crucified nude woman wearing a gas mask, juxtaposing
text and image in a graphically provocative way to
address similar themes to Haring's works. The works by
these artists, addressing the political climates of their
respective milieux, have their roots in modernist move-
ments like Dada, with artists such as Hannah Höch and
Raoul Hausmann both using collage and photomontage
as forms of personal protest following the atrocities of
the First World War.

    Haring's art developed in the 1970s and 1980s, at
a time when conservative governments came to power
in a number of Western countries; Margaret Thatcher was
elected prime minister of the United Kingdom in 1979,
Helmut Kohl came to power as chancellor of the Federal
Republic of Germany in 1982, and Ronald Reagan served
as president of the United States from 1981 to 1989. At
the same time, America endured a fiscal crisis, with the oil
crises of 1973 and 1979 leading to an economic recession
that caused New York City to come close to bankruptcy.
During these turbulent decades, protests were a common
occurrence, and they would become a prominent feature
of Haring's life and practice. In this context, it is clear
that the artist sent many artworks into the world under

Tseng Kwong Chi,
*Keith Haring at
Free South Africa
Anti-apartheid event
Central Park,
New York 1985*,
Muna Tseng Dance
Projects, Inc

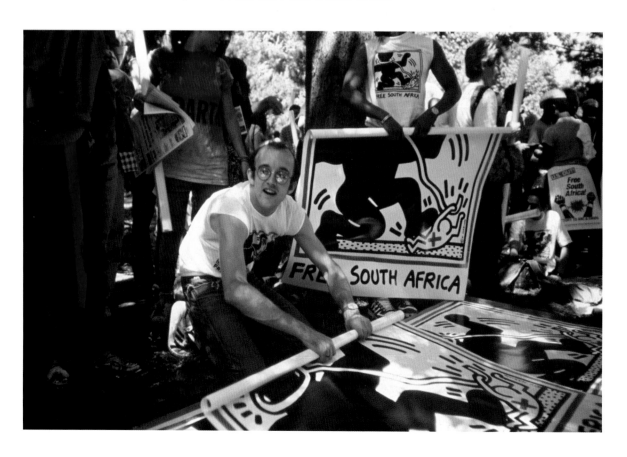

the traditional mantle of activism. The posters he produced addressing various political concerns, which he also distributed himself, are the most tangible proof of this. During an anti-nuclear protest in Central Park in 1982 he handed out 20,000 posters, enlisting the help of his close friend and roommate Samantha McEwen, his boyfriend Juan Dubose, and other friends (p.85).

While the posters were a useful way to quickly disseminate his message, the subjects of Haring's protests also found their way into other aspects of his practice. During the 1980s, the anti-Apartheid movements in both Europe and North America gained widespread support, with rapidly decreasing investment putting pressure on South Africa's government. Haring's iconic *Free South Africa* poster was used by many as part of political protests (p.78). However, he created many more artworks relating to his anti-Apartheid stance, such as the large painting *Untitled (Apartheid)* 1984 (p.99), which comments on colonialism and what he regarded as the distortion of religious doctrine for oppressive means. Having grown up at a time when the civil rights movement was reaching its peak and anti-racism was on the forefront of people's minds, Haring developed a strong opinion on the matter. 'Most white men are evil,' he declared. 'The white man has always used religion as the tool to fulfil his greed and power-hungry aggression. I am ashamed of my forefathers. I am *not* like them.'[6]

Similarly, these subjects come to the fore in Haring's subway drawings – the white chalk drawings that he made on the black papers covering out-of-date New York subway advertisements from 1980 to 1985. Like the covered advertisements themselves, the drawings were designed to reach an incredibly large and diverse audience – they might be seen by thousands of commuters every day. While some of these works were spur-of-the-moment drawings of barking dogs and radiant babies, others responded to current events and were of a more subversive nature. Next to a poster depicting former Ugandan president Idi Amin, Haring drew a large pile of bodies, highlighting the atrocities of the dictator's regime. In others, he responded to the Apartheid struggle, as well as to the excesses of capitalism, in one instance showing a large hand holding burning dollars above a group of figures desperately reaching for the money.

When Haring arrived in New York in 1978, he quickly became immersed in a vibrant, liberal scene that allowed him to freely explore his sexuality. This environment had been fostered by events that took place as part of the gay rights movement of the 1960s and '70s. A key moment had come on 28 June 1969 in Greenwich Village – a raid of the Stonewall Inn in Greenwich Village sparked the

6   *Keith Haring Journals*, 2010, p.164.

spontaneous demonstrations known as the Stonewall riots. In their aftermath, many activist groups emerged and the march that commemorated the first anniversary of the riots became the first of many Pride celebrations.[7] Having grown up in a small, conservative town, the energy of the big city gave Haring a sense of freedom and possibility that is clearly visible in his work from the time, which contains many phallic forms intended to confront the viewer. He wrote: 'All those little abstract shapes I was doing became completely phallic. It was a way of asserting my sexuality and forcing other people to deal with it.'[8]

Though the modern fight for gay rights had already begun in the 1950s, it wasn't until the 1970s that changes slowly began to be made on a governmental level with regard to the treatment of gay people. Until 1973, homosexuality was on the official list of mental disorders of the American Psychiatric Association, and by 1979 less than half of the states had repealed their sodomy laws, with some being forced to do so through legal action.[9] It was not until 1982 that Wisconsin became the first state to outlaw discrimination on the basis of sexual orientation.[10] Though Haring spent much time in New York City's more liberal East Village, homophobia was widespread in the United States, especially due to a conservative political and religious backlash that followed the successes of the gay rights movement. Despite this hostility, Haring used his growing platform to make the marginal visible by creating, exhibiting and selling homoerotic works that foregrounded the subject in the mainstream. In the early years, these works ranged from chalk drawings covered in a repeated phallic motif to a series of ink drawings from 1980 depicting various sexual acts. Later works often combine homoeroticism with political references, as can be seen in *Untitled* 1981 (p.89): the middle figure hangs upside down while those on either side, one masturbating and one missing his genitals, are in the process of castrating him with scissors. With the composition structured by a large black cross, the work seems to reference the Christian church's active disapproval of homosexuality. Far more elaborate is the large canvas from 1984 (p.97), a phantasmagoric composition painted on a solid purple background framed by a yellow edge, these two colours are often used to represent the combination of masculinity and femininity. This untitled work brings together some of Haring's most recognisable motifs – UFOs, pyramids and the nuclear energy symbol – with sexual references, depicting hermaphrodite human/monster hybrids, sodomy and other sexual acts. By using personal experiences to inform the subject matter of his artworks which he presented to the widest possible audience, Haring turned the intimate and the personal into a political statement.

7   Simon Hall, 'Protest Movements of the 1970s: The Long 1960s', *Journal of Contemporary History*, vol.43, no.4, October 2008, pp.656–7.
8   Gruen 1992, p.39.
9   Michael Bronski, *A Queer History of the United States*, Boston, MA 2011, pp.218–19.
10  Daniel Wickberg, 'Homophobia: On the Cultural History of an Idea', *Critical Inquiry*, vol.27, no.1, 2000, p.47.

*National Coming Out Day* 1988, Poster, Offset lithograph on paper, 65.8 × 58.3, Collection Noirmontartproduction, Paris

*Safe Sex!* 1987,
Poster, Offset
lithograph on paper,
74.8 × 69.3, Collection
Noirmontartproduction,
Paris

Despite the efforts of the gay rights movement,
homophobia became increasingly widespread following the
emergence of AIDS in the early 1980s and the fear that
the disease brought with it. Though rumours did not properly
emerge until the following year, the first twenty AIDS cases
were reported in 1981.[11] On 3 July that year, the *New York
Times* published an article under the headline 'Rare
Cancer Seen in 41 Homosexuals' and the term 'gay cancer'
quickly entered public vocabulary. The virus spread
rapidly, becoming a truly catastrophic and widespread
epidemic that soon had an impact on Haring's life. The
crisis changed people's perspective on anonymous sex, and
certain clubs and bathhouses were closed in an attempt
both to stop the virus from spreading and to have greater
control on expressions of sexuality.[12] Haring actively
started promoting safe sex, enabling a more open conver-
sation by creating posters and stickers and designing
condom boxes featuring his 'Safe Sex' and 'Three-Eyed
Face' images. AIDS also became a prominent subject in his
works made from 1986 onwards, which featured threat-
ening skeletons with clocks for eyes and figures being
strangled by their own penises. The voices of artists like

Haring were vital when the US government remained silent on the rapidly growing epidemic. It was not until 17 September 1985, by which point 5,636 Americans had died, that President Reagan first acknowledged the AIDS crisis in public.[13]

Haring himself was diagnosed with AIDS in 1988 and reflecting on this, he stated:

> I was here at the peak of the sexual promiscuity in New York. I arrived, fresh from coming out of the closet, at the time and place where everyone was just wild. I was major into experimenting. If I didn't get it, no one would. So I knew. It was just a matter of time.[14]

Knowing that his time was limited, the artist's drive to produce work increased even further. Rather than becoming insular, his diagnosis caused him to share messages about AIDS and safe sex more actively, both through his art and protests. He frequently joined demonstrations held by ACT UP (AIDS Coalition to Unleash Power) and his bathroom mural *Once Upon a Time* 1989, celebrating homosexuality, still exists in the birthplace of the activist group – The Lesbian, Gay, Bisexual & Transgender Community Center in Greenwich Village. As part of the fight against AIDS, Haring continued creating and distributing his posters, such as *Ignorance = Fear* 1989 (p.122). His painting *Silence = Death* 1989 (p.106) was inspired by the work of Gran Fury, a group of artists affiliated with ACT UP. It presents his characteristic figures against a background of the pink triangle, a symbol for the LGBT community, as they cover their mouths, eyes and ears. The activist imagery combined with the iconic title forms a strong response to the lack of urgency and acknowledgement of the extent of the crisis on the part of the US government.

The posters that Haring created, and which formed an important part of many protests, are tangible proof of his more traditional political activism. However, this category only covers a small part of his work, and highlighting these works alone would fail to do justice to the fundamentally subversive nature of his art. Haring turned the act of painting and drawing itself into a form of activism, using his platform to address sociopolitical issues at a time of significant change on a global level. Moving from the realm of counterculture into popular culture, he used the existing systems of commercial advertising and the art world to disseminate his message in support of the marginalised. At a time when homophobia was rife and the growing AIDS crisis was met with silence from the government, the voices of prominent figures such as Haring were essential **PD & TH**

11 E.J. Fordyce, T.P. Singh, F.M. Vazquez and others, 'Evolution of an Urban Epidemic: The First 100,000 AIDS Cases in New York City', *Population Research and Policy Review*, vol.18, no.6, December 1999, pp.523–44.

12 Bronski 2011, p.227.

13 Ronald Reagan's thirty-second news conference, The White House, 17 September 1985, transcript accessed via the Ronald Reagan Presidential Library. https://www.reaganlibrary.gov/research/speeches/91785c

14 David Sheff, 'Keith Haring: Just Say Know', *Rolling Stone*, no.558, 10 August 1989., pp.58–66.

# Messages to the Public

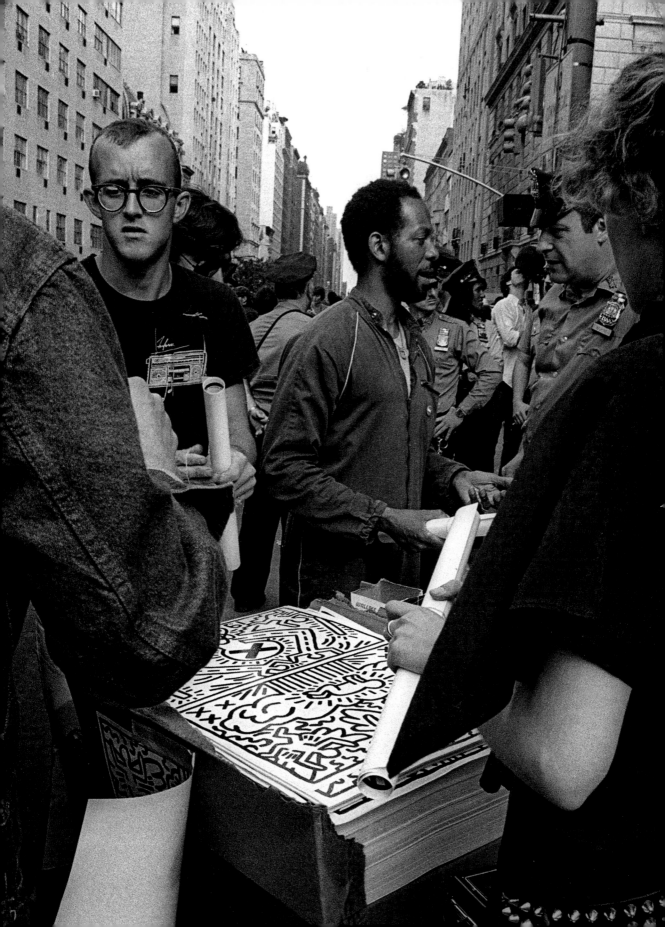

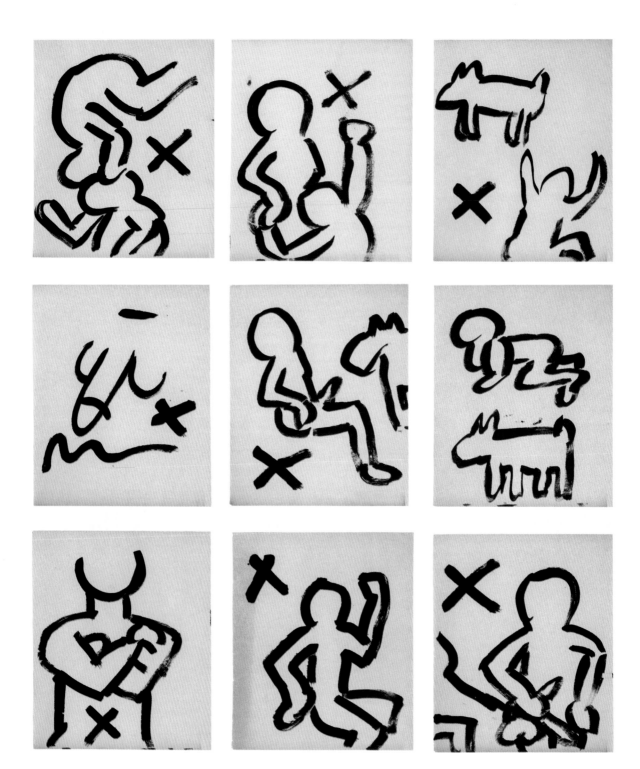

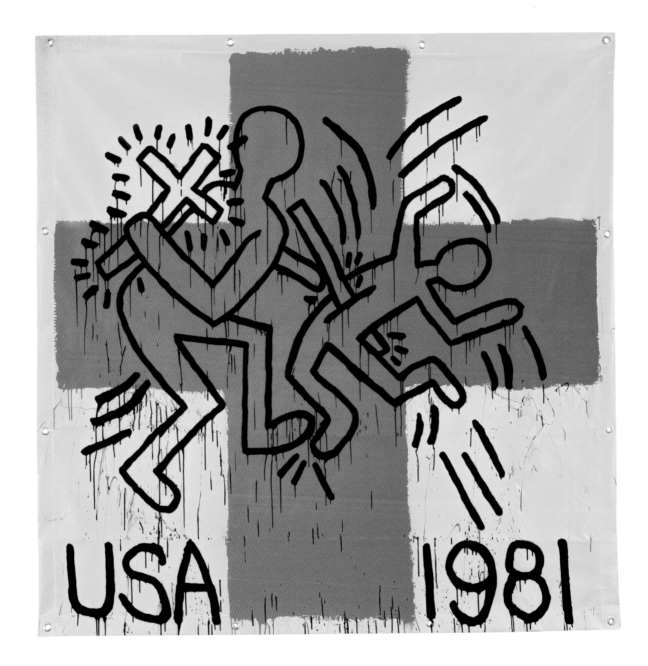

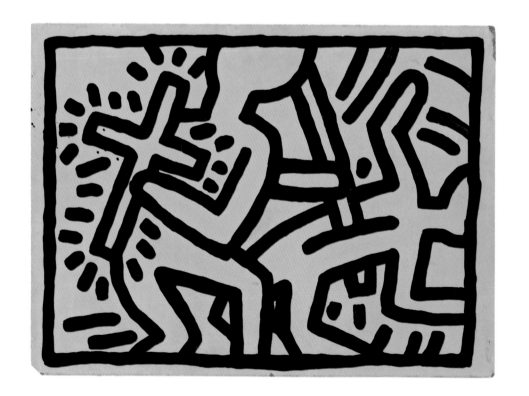

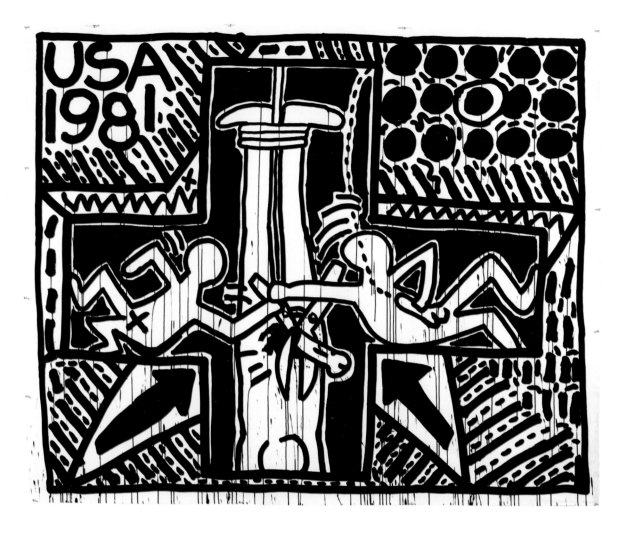

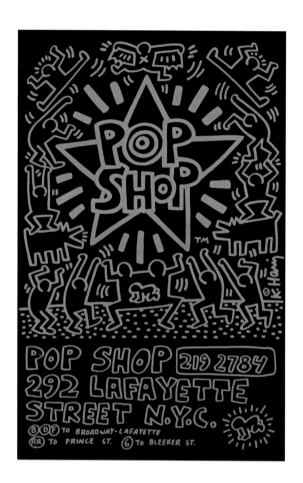

UNTITLED BY KEITH HARING FOR NELSON MANDELA 70TH BIRTHDAY TRIBUTE "THE STRUGGLE IS MY LIFE. I WILL CONTINUE FIGHTING FOR FREEDOM UNTIL THE REST OF MY DAYS"

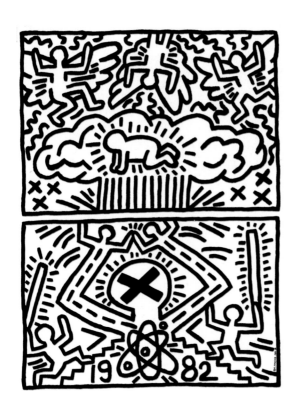

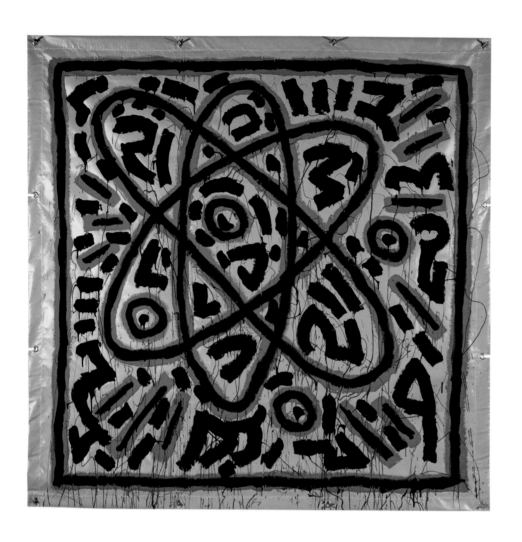

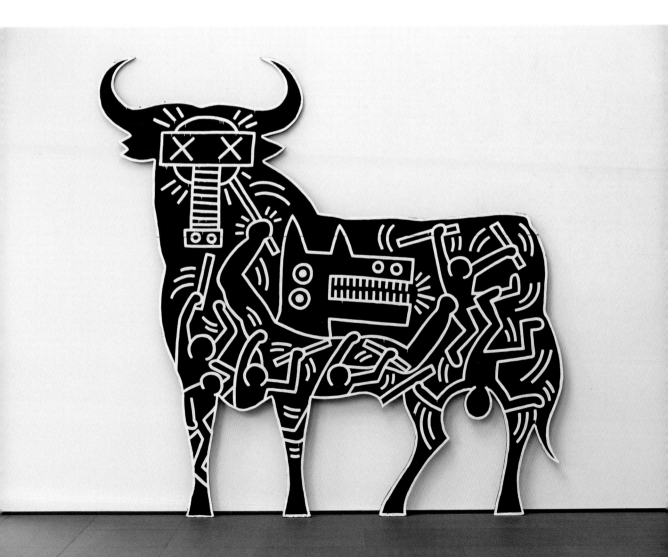

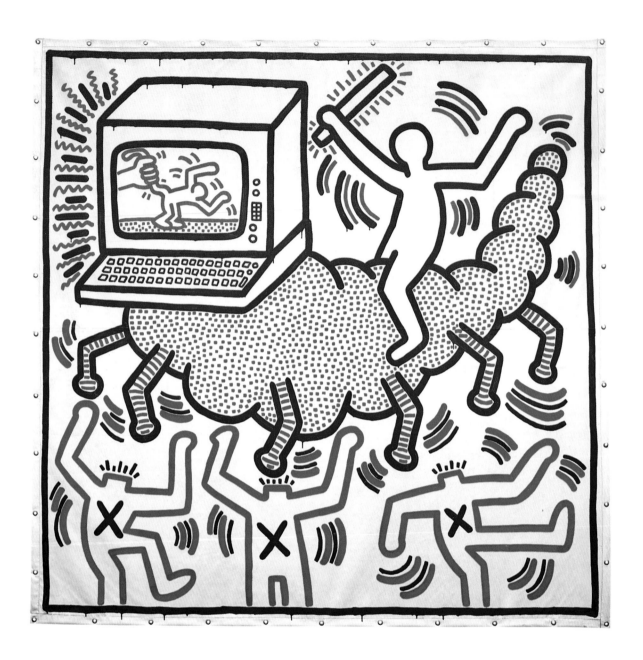

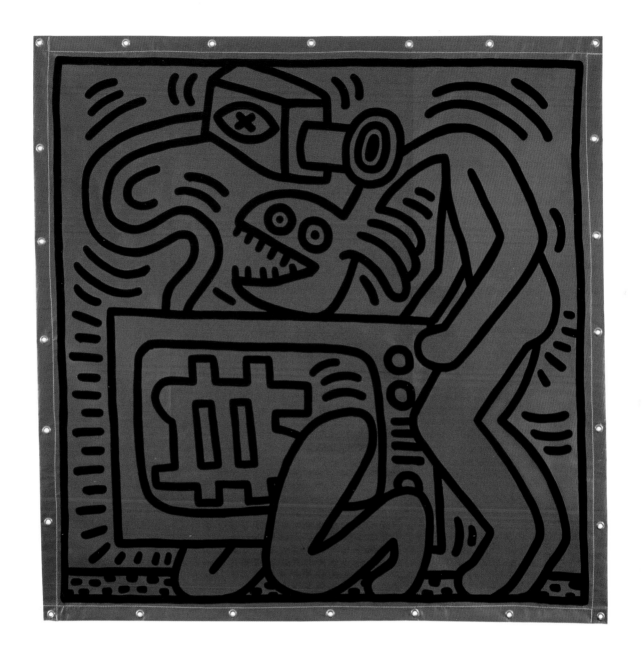

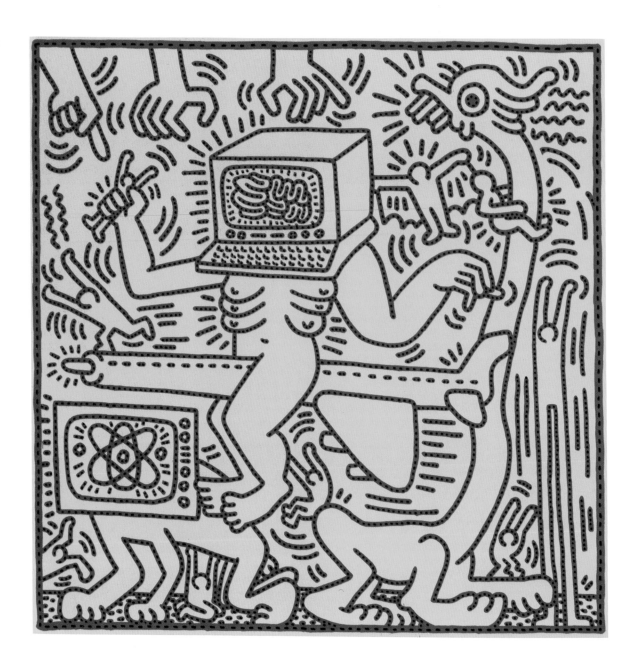

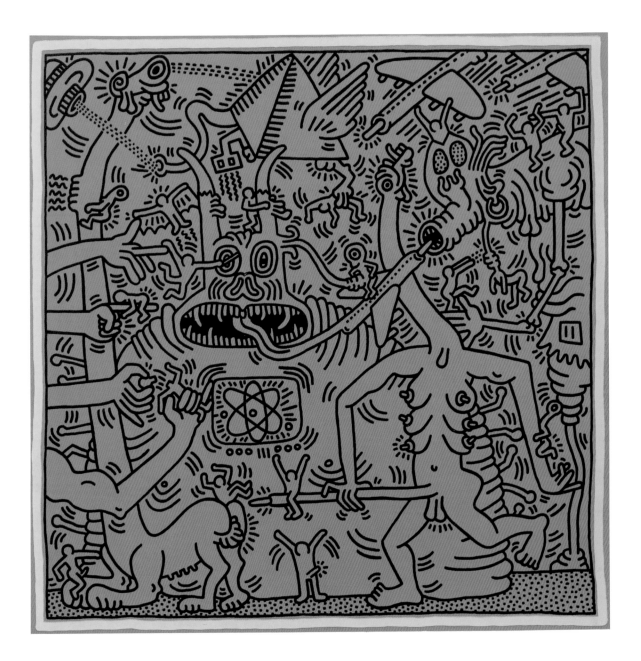

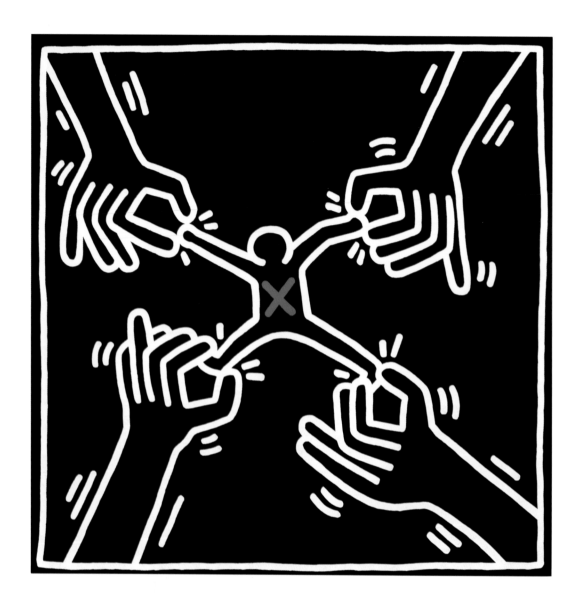

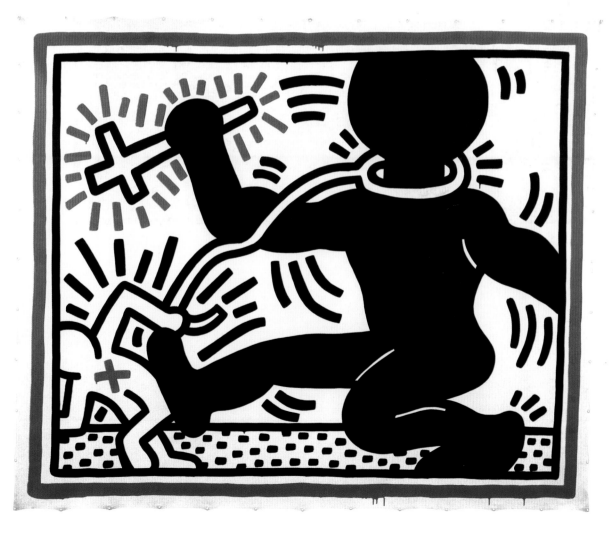

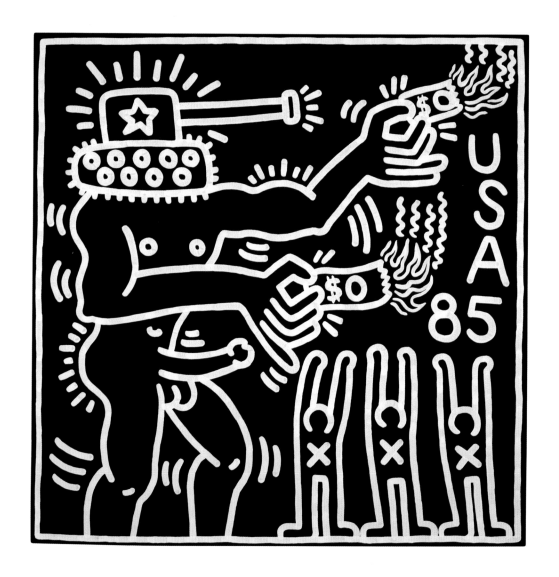

100

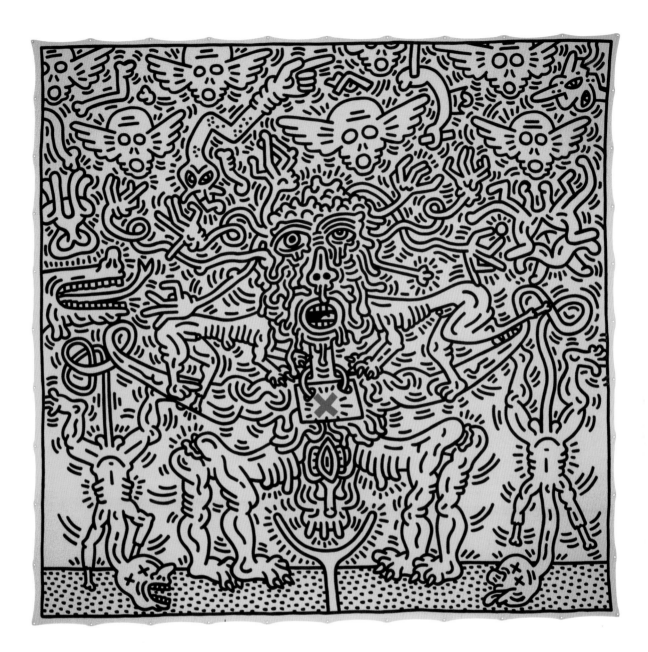

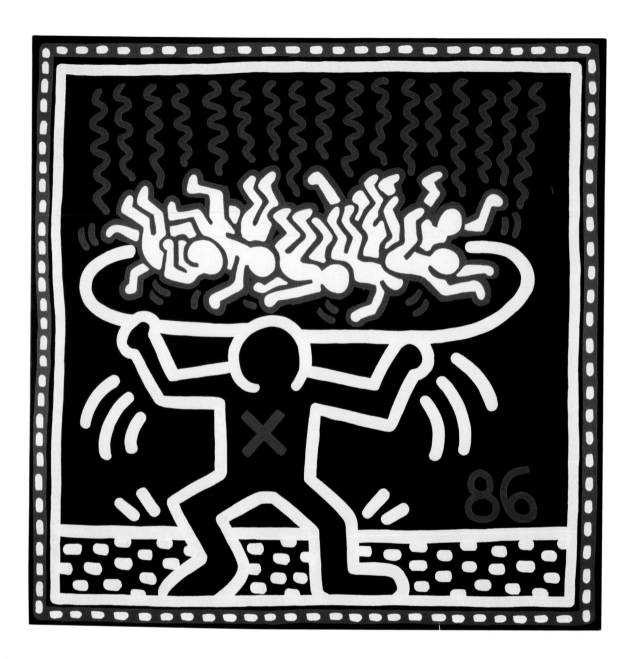

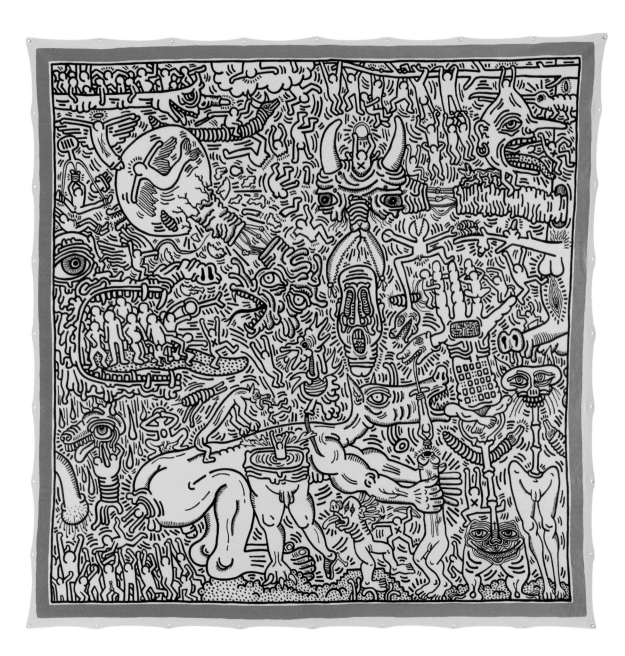

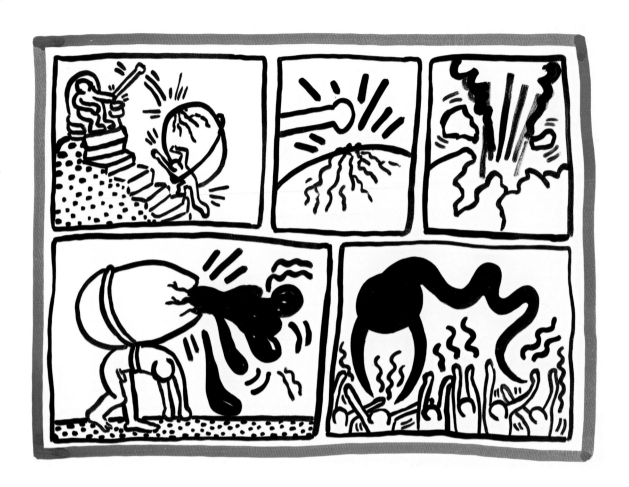

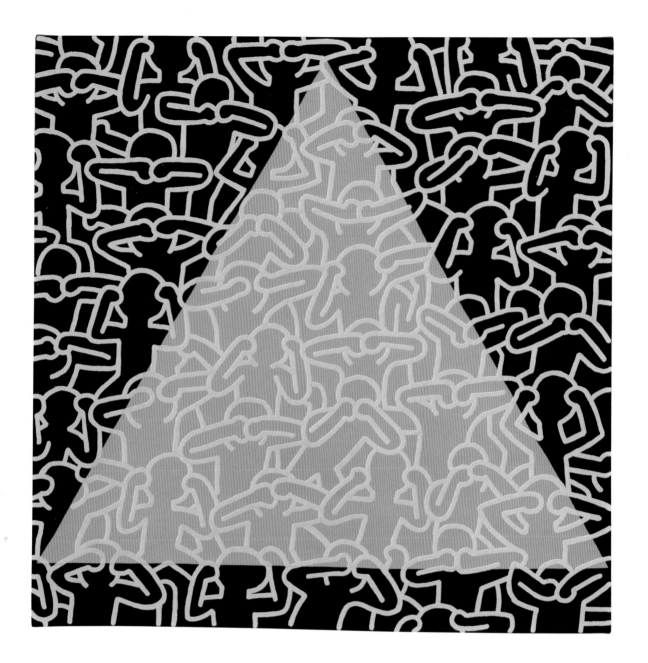

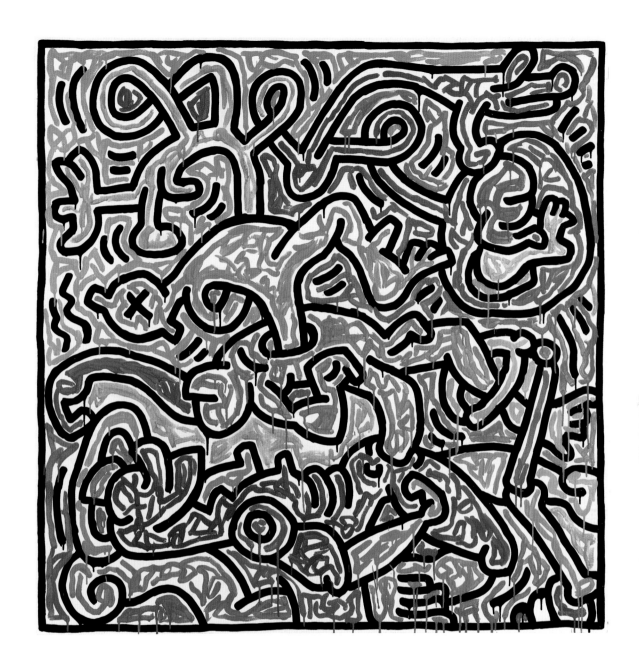

[p.85]
Joseph Szkodzinski,
*Keith Haring with
Samantha McEwen and
Juan Dubose handing
out free posters at
an antinuclear rally,
New York*, 12 June 1982

[p.86]
*Untitled (Figure
Drawings)* c.1980,
Ink on paper, nine
drawings, each
40.6 × 35.5, Collection
of Larry Warsh

[p.87]
*Untitled* 1981,
Vinyl ink on tarpaulin,
182.9 × 182.9,
Private collection,
Europe

[p.88]
*Untitled* 1982,
Ink and oil paint on
wood, 31 × 42.5,
BvB Collection, Geneva

[p.89]
*USA 1981* 1981, Gouache
and ink on paper,
183 × 231, Collection of
the Keith Haring
Foundation

[p.90]
*Pop-Shop* 1986,
Poster, Offset lithograph
on paper, 86.2 × 55.8,
Collection
Noirmontartproduction,
Paris

[p.90]
*Crack Down* 1986,
Poster, Offset lithograph
on paper, 55.8 × 43.2
Collection
Noirmontartproduction,
Paris

[p.90]
*New York is Book Country*
1985, Poster, Offset
lithograph on paper,
64.5 × 50, Collection
Noirmontartproduction,
Paris

[p.90]
*Nelson Mandela 70th
Birthday Tribute* 1988,
Poster, Offset lithograph
on paper, 59.4 × 42.1,
Collection
Noirmontartproduction,
Paris

[p.91]
*Poster for Nuclear
Disarmament* 1982,
Poster, Offset lithograph
on paper, 61 × 45.6,
Collection
Noirmontartproduction,
Paris

[p.91]
*Break Weapons not
Spirits* 1988, Poster,
Offset lithograph
on paper, 43 × 27.9,
Collection
Noirmontartproduction,
Paris

[p.91]
Keith Haring,
Jean-Michel Basquiat,
Roy Lichtenstein,
Yoko Ono, Andy Warhol,
*Rain Dance* 1985,
Poster, Offset lithograph
on paper, 78.6 × 55.8,
Collection
Noirmontartproduction,
Paris

[p.91]
*City Kids Speak on
Liberty* 1986, Poster,
Offset lithograph
on paper, 60.9 × 48.3,
Collection
Noirmontartproduction,
Paris

[p.92]
*Untitled* 1982, Acrylic
paint on vinyl tarpaulin
with metal grommets,
183.5 × 183.5,
Private Collection,
courtesy of
Martin Lawrence
Galleries

[p.93]
*Untitled* 1983,
Acrylic paint on wood,
303 × 300,
Esther Grether Family
collection

[p.94]
*Untitled* 1983,
Vinyl paint on
tarpaulin, 306.8 × 302,
Collection of KAWS

[p.95]
*Untitled* 1984,
Vinyl paint on vinyl
tarpaulin, 186.1 × 186.1,
Collection of Julie and
Edward J. Minskoff

[p.96]
*Untitled*, 31 May 1984,
Acrylic paint on canvas,
238.8 × 238.8,
Private collection

[p.97]
*Untitled* 1984,
Acrylic paint on canvas,
238.8 × 238.8,
Lune Rouge Collection

[p.98]
*Untitled* 1985,
Acrylic paint on canvas,
150 × 150, Collection
Alona Kagan

[p.99]
*Untitled (Apartheid)*
1984, Acrylic paint
on canvas, 300 × 365,
Collection Stedelijk
Museum Amsterdam

[p.100]
*Untitled*, April 9 1985,
Acrylic paint on
canvas, 152.4 × 152.4,
Collection of
the Keith Haring
Foundation

[p.101]
*Untitled* 1985,
Acrylic paint and oil
paint on canvas,
304.8 × 304.8,
Ludwig Forum für
Internationale Kunst
Aachen, loan of
the Peter and Irene
Ludwig Foundation

[p.102]
*Untitled* 1986,
Acrylic paint on canvas,
152.5 × 152.5, Courtesy
Van de Weghe Fine Art,
New York

[p.103]
*Untitled*, September 23,
1986, Acrylic paint and
oil paint on tarpaulin,
243.8 × 243.8,
Private collection

[p.104–5]
*Untitled* 24 April 1988,
Set of Ten Drawings,
Gouache and ink
on paper, 56.5 × 76.2,
Esther Grether
Family Collection

[p.106]
*Silence = Death* 1989,
Acrylic paint on
canvas, 101.6 × 101.6,
Private collection,
Belgium

[p.107]
*Untitled* 1989,
Acrylic paint
on canvas, 150 × 150,
Private collection

[p.108]
*Untitled* 1987,
Acrylic paint and
ink on canvas,
180.5 × 180.5,
Private collection

# Keith Haring Timeline 1958–1990

by Tamar Hemmes

Keith Haring 1969
Photograph
taken by his father
Allen Haring

## 1958

Keith Haring is born on 4 May in Reading, Pennsylvania, to parents Allen and Joan Haring. Raised in nearby Kutztown, Haring grows up with three younger sisters: Kay, Karen and Kristen.

## 1960

9 May – Birth control pill approved for commercial use in the United States, granting greater reproductive freedoms to women.

## 1961

12 April – Russian cosmonaut Yuri Gagarin becomes the first human to orbit the Earth. Gagarin's flight comes at a time when the United States and Soviet Union are competing for technological supremacy in space.

13 August – Construction of the Berlin Wall begins, creating a physical barrier between the East and West sides of the city.

## 1962

Andy Warhol's famed studio The Factory, located in Midtown Manhattan from 1962 to 1967, becomes a hip hangout for artistic types.

16 October – The Cuban Missile Crisis begins – a thirteen-day confrontation between the United States and the Soviet Union, which threatens to escalate into a full-scale nuclear war.

## 1963

28 August – Civil rights activist Martin Luther King Jr delivers his 'I Have a Dream' speech to over 250,000 civil rights supporters from the steps of the Lincoln Memorial in Washington, D.C.

22 November – Assassination of John F. Kennedy in Dallas, Texas.

## 1964

2 July – Civil Rights Act ends segregation in public places and bans employment discrimination based on race, colour, religion, sex or national origin.

**Haring's father instils in him a love of cartooning and drawing. 'My dad made cartoon characters for me, and they were very similar to the way I started to draw – with one line and a cartoon outline.'[1] Aside from his father, the artist cites the cartoon characters of Dr Seuss and Walt Disney as some of his earliest influences.**

## 1968

4 April – The assassination of Martin Luther King Jr in Memphis, Tennessee, leads to a wave of civil disturbances across the United States.

## 1969

28–29 June – Stonewall riots, Greenwich Village, New York City. This becomes a key moment for the gay rights movement and many activist groups emerge in its wake.

20 July 1969 – Apollo 11 lands on the moon, with Neil Armstrong stepping out on to the lunar surface the next day.

As a child, Haring attends church and Sunday school. Wanting to belong to a group, he briefly joins the countercultural Jesus Movement, becoming a 'Jesus Freak' and encouraging people to be reborn. He soon becomes disillusioned with this and begins experimenting with hallucinogenic drugs. Haring later employs religious iconography in his works, including his signature 'Radiant Baby', the rays indicating a 'spiritual light glowing from within'.[2]

---

1 John Gruen, *Keith Haring: The Authorized Biography*, New York and London 1992, p.9.

2 Natalie E. Phillips, 'The Radiant (Christ) Child: Keith Haring and the Jesus Movement', *American Art*, vol. 21, no.3, 2007, pp.54–73. JSTOR, www.jstor.org/stable/10.1086/526480

**1972**
17 June – Beginning of the Watergate scandal, stemming from illegal activities undertaken by President Richard Nixon's administration, leading to his resignation on 9 August 1974.

**1973**
10 December – CBGB music venue opens in Manhattan's East Village. The venue becomes synonymous with punk rock and the New Wave scene, hosting bands including The Ramones, Blondie and Talking Heads.

15 December – the American Psychiatric Association removes homosexuality from its Diagnostical and Statistical Manual of Mental Disorders.

**1975**
30 April – The Fall of Saigon brings the Vietnam War to an end.

**1976**
Haring enrols at the Ivy School of Professional Art in Pittsburgh and is encouraged by his parents and guidance counsellor to pursue a commercial art degree. However, he soon realises that he has no desire to become an illustrator or graphic designer and drops out, declaring his intention to become an artist. He continues to work in a self-determined way.

**1977**
The Public Art Fund is founded by Doris C. Freedman, with a focus on supporting artists in New York City. The organisation would support the realisation of several of Haring's public projects.

**1978**
16 October – Election of Pope John Paul II, who throughout his papacy takes a strong stance against contraception, abortion and homosexuality.

Polaroid image of
Keith Haring and
Juan Dubose 1983,
Montreux

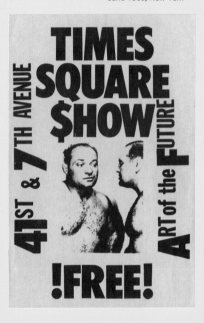

In 1978, Haring begins to find inspiration in the work of other artists, including Fernand Léger, Pablo Picasso and Frank Stella, as well as other cultures, with influences including Japanese calligraphy, Aztec symbolism and ancient Egyptian hieroglyphs. Rather than directly adopting these styles, he synthesises them into a uniquely personal aesthetic; 'I hope I'm not vain in thinking that I may be exploring possibilities that artists like Stuart Davis, Jackson Pollock, Jean Dubuffet and Pierre Alechinsky have initiated but did not resolve. Their ideas are living ideas.'[3]

While visiting an exhibition by Belgian painter Pierre Alechinsky at the Carnegie Museum of Art in Pittsburgh (28 October 1977 – 8 January 1978), Haring discovers a stylistic similarity in their work, giving him confidence to pursue an artistic career of his own.[4] He has the first of two solo exhibitions at the Pittsburgh Centre

for the Arts, where he has been working doing odd jobs and repair works. He uses the facilities there to create large abstract paintings.

In autumn 1978, Haring relocates to New York City to commence studies at the School of Visual Arts (SVA). He is taught by artists including Bill Beckley, Lucio Pozzi, Simone Forti, Barbara Schwartz and Keith Sonnier. The discovery of video work has a significant impact on Haring: 'Video – a medium capable of reaching higher levels of communication – more direct, more involved than painting/sculpture.' It makes him increasingly aware of the importance of movement and performance as part of his painting.[5]

27 November – Politician and gay rights activist Harvey Milk is assassinated in San Francisco, California.

## 1979

28 March – An accident at Three Mile Island nuclear plant, not far from Kutztown, leads to release of radioactive gas. The nuclear energy symbol appears in many of Haring's later works.

In 1979, Haring moves to New York's East Village, a multicultural creative scene he refers to as a 'gay Disneyland'. Haring becomes immersed in the vivid underground art and club scenes: 'It was just exploding ... There was a migration of artists from all over America to New York. It was completely wild. And we controlled it ourselves.'[6]

---

3  *Keith Haring Journals*, New York and London 2010, p.29.
4  David Sheff, 'Keith Haring: Just Say Know', *Rolling Stone*, no.558, 10 August 1989. https://www.rollingstone.com/culture/culture-news/keith-haring-just-say-know-71847/
5  *Keith Haring Journals*, 2010, p.20.
6  Sheff 1989
7  Gruen 1992, p.57

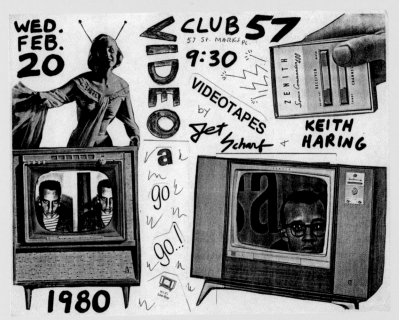

Flyer for 'Video A-Go-Go', videotape screenings by Keith Haring and Kenny 'Jet' Scharf, 20 February 1980, Collection of the Keith Haring Foundation

*Still from Video Tape for Two Monitors* 1980, Video, black & white, sound; digital transfer, Collection of the Keith Haring Foundation

This explosion of creativity and a lack of gallery opportunities results in the street becoming a space for exhibiting art. Artists begin to infiltrate social and public spaces with their work. Having seen the tag 'SAMO' spray-painted on the New York streets for almost a year, Haring finally meets its creators, Jean-Michel Basquiat and Al Diaz. Basquiat would become a friend and a rival to Haring.

Haring and his friends, including fellow SVA student Kenny Scharf, become regulars at Club 57, a nightclub-cum-theatre-cum-arts venue situated in the basement of a Polish Church on St Mark's Place. Haring curates numerous shows featuring work by artists from his immediate circle.

## 1980

In the summer of 1980, Haring is becoming increasingly recognised as an artist and drops out of SVA, feeling that he can no longer learn anything new there. He becomes more and more involved in the underground art scene and is intrigued by the graffiti he sees around him in the city.

June – The Sony Walkman is launched for commercial distribution in the United States.

In the winter, Haring begins drawing on the streets, developing a language of vividly communicative pictographs. The baby becomes his tag, while his 'CLONES GO HOME!' stencils identify a territorial boundary between the East and West Village gay communities. Rearranging headlines from the *New York Post*, Haring creates collages stating, 'POPE KILLED FOR FREED HOSTAGE' and 'REAGAN SLAIN BY HERO COP'; 'I Xeroxed these in the hundreds and I'd paste them on lamp posts and on news stands. Because they looked so real, people

were forced to confront them. They were completely confused – and the posters really made a mark, because they got into people's consciousness.'[7]

Many graffiti artists are using the New York trains and subway system as their canvas, tagging and spray-painting them until they are completely covered. One day, while riding the subway, Haring's eye is drawn to the black paper used to cover old advertisements. Inspired to use the public space for his work, he immediately buys white chalk and begins drawing. This is the start of Haring's subway drawings, which he makes for five years, sometimes creating up to forty in a single day. The subway provides a platform for Haring to access an incredibly large and diverse audience, and the interaction with commuters is an integral part to the work. As part of the performance of creating these works, Haring hands out pin-badges, spreading his imagery even further.

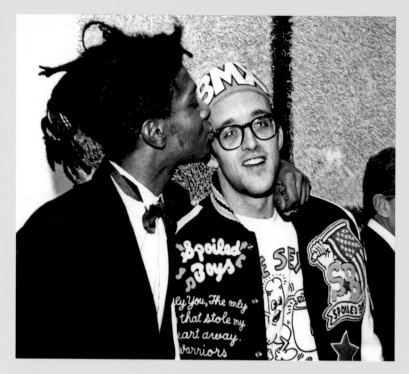

George Hirose,
Jean-Michel Basquiat
and Keith Haring
at the opening of
the Julian Schnabel
retrospective,
Whitney Museum
of American Art,
New York, 1987

8 December – John Lennon is shot
dead outside his New York apartment,
near Central Park.

'Someone came into the Mudd Club and
told us that John Lennon had been shot.
People couldn't believe it. It had this
incredibly sobering effect on the entire city.
I woke up the next morning with this image
in my head – of the man with a hole in
his stomach – and I always associated that
image with the death of John Lennon.'[8]

8  Ibid., p.70.
9  E.J. Fordyce, T.P. Singh, F.M. Vazquez and others,
   'Evolution of an Urban Epidemic: The First 100,000
   AIDS Cases in New York City', *Population Research
   and Policy Review*, vol.18, no.6, December 1999,
   pp.523–44.
10 *Keith Haring Journals*, 2010, p.23.

## 1981

Haring is increasingly gaining attention
for his work, with exhibitions at Westbeth
Painters Space (10–14 February), Club 57
(12 May) and a second show at P.S. 122
(18 October to 2 November). He also takes
part in the group show *New York/New Wave*
at PS1 in Long Island City (15 February
– 5 April), an important exhibition curated by
Diego Cortez that also includes work by
Jean-Michel Basquiat, Nan Goldin, Robert
Mapplethorpe and Andy Warhol. He also
appears in *Drawing Show* at the Mudd Club
(22 February – 15 March). In addition to
displaying his own work, Haring organises
short exhibitions at Club 57, including the
*Erotic Art Show* (12 February) and (with
Fred Brathwaite aka Fab 5 Freddy) the *Black
Light Art Show* (3 – 4 June), and at the Mudd
Club, including the graffiti show *Beyond
Words* (9–24 April), curated, at Haring's
request, by Fab 5 Freddy and Futura 2000.

20 January – Ronald Reagan is elected
president of the United States.

30 March – President Reagan survives
an assassination attempt.

12 April – First launch of the Space Shuttle
*Columbia*.

June – First AIDS cases reported. The HIV
virus becomes a catastrophic epidemic,
with New York accounting for many victims.[9]

3 July – The *New York Times* publishes an
article titled 'Rare Cancer Seen in 41
Homosexuals'. The term 'gay cancer' enters
public vocabulary. It is not until 27 July the
following year that the epidemic is identified as
AIDS (Acquired Immune Deficiency Syndrome).

Haring moves into a large apartment on
Broome Street in lower Manhattan with his
friend Samantha McEwen and his then
boyfriend Juan Dubose. To maintain a sense
of privacy, Haring and Dubose turn a
camping tent into their bedroom. The space
in the basement becomes his first studio.

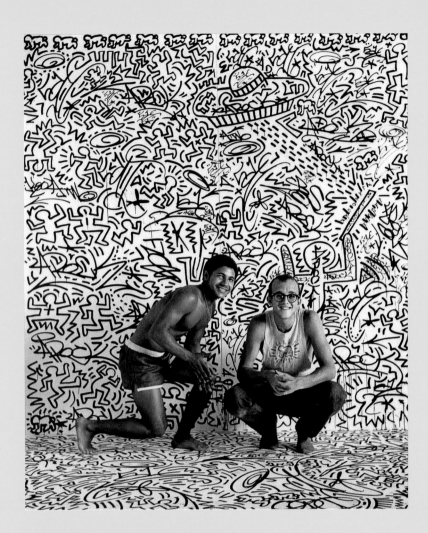

Tseng Kwong Chi,
*Keith Haring and
LA II (Angel Ortiz)
collaboration* 1982,
Muna Tseng Dance
Projects, Inc

1 August – MTV (Music Television) is launched in the United States, offering a visual platform for musicians. In the coming years Haring appears on MTV and designs graphics for the channel.

Television and computer screens increasingly appear in Haring's work at this time, often replacing the heads of his signature figures in a comment on the pervasive power of mass media. The 1980s witness a rapid development of information technology and video games for entertainment purposes. Haring's awareness, and perhaps concern, regarding these advances, is evident in several of his large-scale paintings, such as the yellow work *Untitled* 1984, depicting an isolated brain on one screen and an atomic symbol on the other. 'The silicon computer chip has become the new life form. Eventually the only worth of man will be to service and serve the computer ... It appears to me that human beings have reached an end in the evolutionary process. We will, if we continue on the same path, eventually destroy ourselves.'[10]

## 1982

As Haring becomes increasingly well-known he is inundated with studio visits from collectors. Overwhelmed by this attention, he agrees to be represented by Tony Shafrazi, the Soho gallerist for whom he has temporarily worked as a gallery assistant. Preparations begin immediately for his first solo exhibition at the gallery, which includes collaborative pieces made with the fourteen-year-old LA II ('Little Angel', Angel Ortiz), a graffiti artist whom Haring sought out, and with whom he works collaboratively for the following four years. The exhibition includes Haring's first paintings on vinyl tarpaulins, and drawings, as well as painted objects including decorated vases.

Haring is invited to take part in international exhibitions, including a first European showing in Rotterdam (April–June) and the prestigious Documenta 7 in Kassel, Germany (June–September). He realises a number of other projects, including

an animated work for the Spectacolor billboard in Times Square in January (a project organised by the Public Art Fund), and his first public mural, on Houston Street in downtown New York, in June.

The activism in Haring's work is foregrounded by his involvement in an anti-nuclear rally in New York's Central Park on 12 June 1982. As part of this, Haring and a group of his friends hand out 20,000 of his self-published posters.

September – *Wild Style*, cult film capturing the energy of the emergent hip-hop and street art scene, directed by Charlie Ahearn, receives its theatrical release.

5 November – The highest unemployment rate since 1940 is recorded in the United States. By the end of the month more than eleven million people are unemployed.

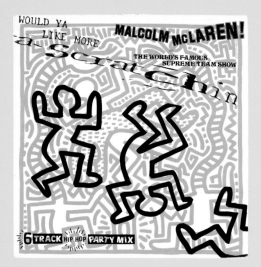

Scratchin' 1984,
Vinyl LP with sleeve
designs by Keith Haring,
31.3 × 31.3,
Collection
Noirmontartproduction,
Paris

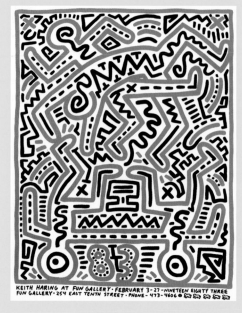

Keith Haring at Fun
Gallery 1983, Poster,
Offset lithograph
on paper, 74.3 × 58.3,
Collection
Noirmontartproduction,
Paris

Keith Haring and
Andy Warhol at
the American
Foundation for AIDS
Research fundraiser,
Jacob Javits Center,
New York, May 1986,
Collection of
the Keith Haring
Foundation

## 1983

Haring finally meets his idol Andy Warhol at the opening of his solo show at the Fun Gallery (3 to 27 February 1983), for which he again collaborated on works with LA II. This gallery had been founded by Patti Astor in 1981, and championed the street art scene, presenting exhibitions of works by Fab 5 Freddy (Fred Brathwaite), Lee (Quinones), Zephyr, Dondi, Lady Pink and Futura 2000, as well as Haring and Basquiat. Warhol, a leading pop art figure since the 1960s, soon becomes both friend and mentor to the younger artist.

Artist Klaus Nomi, Haring's friend and fellow Club 57 performer, succumbs to AIDS-related complications on 6 August. He is the first of the artist's social circle to fall victim to the HIV virus.

Haring's international recognition increases significantly, and he is invited to show his work in more exhibitions outside of the US. Rather than shipping works to different locations, he travels around the world to create new paintings on-site for exhibitions at Watari Gallery in Tokyo (8 March to 8 April 1983) and Lucio Amelio Gallery in Naples (May). As part of an exhibition at Robert Fraser Gallery in London (19 October – 12 November), Haring body-paints choreographer and director Bill T. Jones. His work is also included in biennial exhibitions at the Whitney Museum of American Art in New York and in São Paulo, Brazil.

28 September – Death of graffiti artist Michael Stewart in police custody. Many consider his death an act of racism and police brutality. Both Basquiat and Haring create tribute paintings in response.

13 October – The first ever commercial mobile phone call is made.

Following a meeting in New York, Haring collaborates with the British fashion designers Vivienne Westwood and Malcolm McLaren for their Witches collection of winter 1983/84.

11 'AIDS in New York: A Biography', New York, http://nymag.com/news/features/17158/index1.html
12 Keith Haring Journals, 2010, p.133.

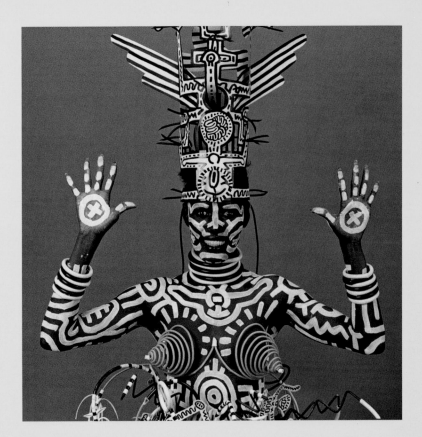

Robert Mapplethorpe, *Grace Jones* 1984, Photograph, gelatin silver print on paper, Robert Mapplethorpe Foundation / © Tate

## 1984

January – Despite New York being an epicentre of the growing AIDS epidemic, Mayor Koch has only spent $24,500 in response. Tens of thousands of New Yorkers are already infected, while 864 have died.[11] Cities like San Francisco are similarly affected.

24 January – The first Macintosh computer is launched.

Haring's second show at Tony Shafrazi Gallery takes place under the title *Into 84* (3 December 1983 – 7 January 1984). Still resistant to the idea of occupying a traditional art space, the artist transforms the gallery into a club, presenting his Day-Glo works in a black-light room, with his boyfriend Juan Dubose acting as DJ.

Over the course of this year, Haring creates a number of *pro bono* community projects, including murals in Melbourne and Sydney and at the Children's Village in New York, a charitable organisation working with vulnerable children. The kids' sense of humour, honesty and lack of prejudice resonates with the child-like side of the artist's personality: 'Children possess a fascination with their everyday existence that is very special and would be helpful to adults if they could learn to understand and respect it. I am now 28 years old on the outside and nearly 12 years old on the inside. I always want to stay 12 years old on the inside.'[12]

16 May – Madonna performs 'Dress You Up', wearing a Keith Haring and LA II embellished pink leather suit, and, having changed into white frills, previews 'Like a Virgin' at his 'Party of Life' birthday celebration at Paradise Garage, New York. That September, she performs her global hit 'Like a Virgin' at the inaugural MTV Awards.

On 24 July, Haring decorates the body of singer Grace Jones in his white marks and visual motifs while Warhol and Mapplethorpe photograph the process and the end result appears in Warhol's *Interview* magazine of October 1984. Several collaborations follow, as Haring body-paints Jones for performances at the Paradise Garage and collaborates on the music video for her 1986 single 'I'm Not Perfect (But I'm Perfect For You)', which finds wide exposure on MTV.

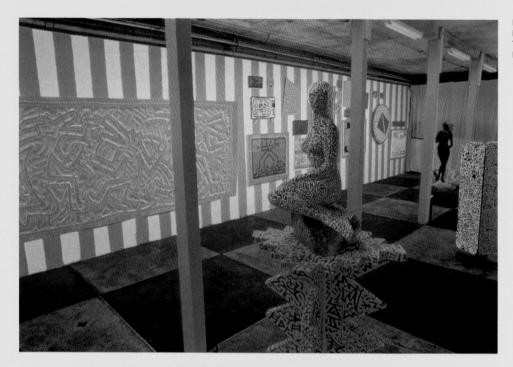

## 1985

In response to the ongoing anti-Apartheid struggle, Haring creates his *Free South Africa* poster, which is used by many as a visual protest during demonstrations. This is followed by a range of other works on the subject, including paintings and subway drawings, with the image also finding expression on printed T-shirts.

The AIDS crisis is now having an increasing impact on Haring's life and social circle and he uses his accessible imagery and public profile to enable conversations on the issue and promote safe sex. At the same time, he continues working with a variety of charitable causes, organising 'Rain Dance', for UNICEF's African Emergency Relief Fund, with a benefit taking place at Paradise Garage on 30 January, and an exhibition running from 2–23 February, in the Soho space that would ultimately house his Pop Shop.

4 March – The first blood test to detect the HIV virus is approved by the US Food and Drug Administration.

After five years of filling subway stations with his iconic visual language, Haring decides to stop creating his chalk subway drawings. He feels he has reached his goal of disseminating his work and messages to the largest possible audience. At the same time, the prices of his artworks have skyrocketed due to his increasing profile and popularity, leading to people cutting the chalk subway drawings out of their frames. Their removal goes directly against Haring's intentions, and the artist looks for different ways to make his work and ideas accessible.

May – Scientists report a substantial 'ozone hole' over the Antarctic, a degradation of the environment caused by man-made chemicals such as chlorofluorocarbons (CFCs).

Following the success of Studio 54, owner Steve Rubell (an early collector of Haring's work) converts the Palladium, an old cinema, into a nightclub which opens in May. Haring is asked to create a permanent, large-scale backdrop for the venue.

13 July – Live Aid, a dual-venue benefit concert raising funds to help relieve the Ethiopian famine, is staged simultaneously in London and Philadelphia.

17 September – President Reagan acknowledges the existence of AIDS during a press conference. A total of 5,636 Americans have already died.[13]

For a joint exhibition at Tony Shafrazi's and Leo Castelli's galleries, Haring creates large-scale metal sculptures (26 October to 23, 30 November, respectively).

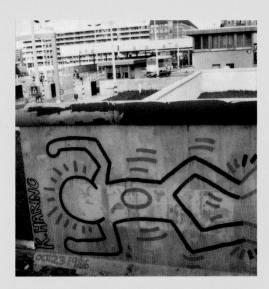

Polaroid image
of Berlin Wall mural,
October 1986

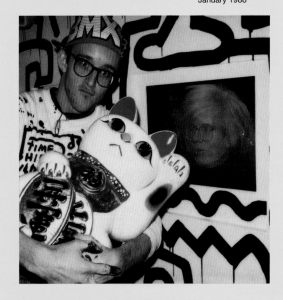

Polaroid image of
Keith Haring at
the Tokyo Pop Shop,
January 1988

As part of his first solo museum exhibition at the Museum of Contemporary Art in Bordeaux, running from 15 December 1985 to 23 February 1986, Haring creates the large-scale work *The Ten Commandments*. 'The way I worked on the "Ten Commandments" is: even though it says "thou shalt not steal", the picture I show is someone stealing: the antithesis. I present what not to do instead of saying "this is what you should do".[14]

### 1986

18 January – The *Challenger* space shuttle explodes shortly after lift-off, killing all seven people on board.

From 15 March to 12 May, Haring shows his work at the Stedelijk Museum in Amsterdam. Part of the show consists of works that were shown in Bordeaux the previous year, though Haring also creates some new additions. While preparing for the exhibition, he paints a mural on the exterior wall of the museum's art storage warehouse.

On 19 April, Haring opens his 'Pop Shop' at 292 Lafayette Street, New York. Though Haring's work evolves over time to become less abstract, his all-over environment style of painting from the late 1970s reappears in his design for the boutique. Selling affordable merchandise such as T-shirts, badges and posters, the shop is an extension of the artist's philosophy that art should be accessible to all, allowing him

to continue the public interaction that started with his subway drawings. It remains open until September 2005.

A second Pop Shop in Tokyo is less successful, due to forgeries of Haring's designs being widely available, at much lower prices, in Japan.

25–26 April – The nuclear plant disaster at Chernobyl in the Soviet Union leads to a dangerous radiation leak and the evacuation of around 116,000 people.

Responding to the crack cocaine epidemic in New York, which affects many people in the East Village, Haring creates his 'Crack is Wack' murals. These works merge a vision of the wider social situation in the city with Haring's personal experience; in 1984 he witnessed the danger of the drug, when his studio assistant Benny Soto, who had ambitions to go to medical school, became addicted to crack.

13 Ronald Reagan's thirty-second news conference, The White House, 17 September 1985, transcript accessed via the Ronald Reagan Presidential Library. https://www.reaganlibrary.gov/research/speeches/91785c

14 Sylvie Couderc (with the collaboration of Sylvie Marchand), 'The Ten Commandments, An Interview', December 1985, http://www.haring.com/!/selected_writing/ten-commandments-an-interview#.XFreB8_7SCQ

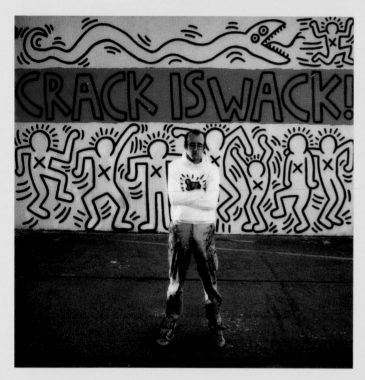

Keith Haring with
'Crack is Wack!' mural,
6 October 1986

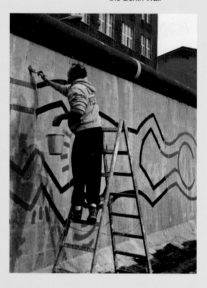

Keith Haring painting
the Berlin Wall

Haring works with 1,000 children on the large-scale project *CityKids Speak on Liberty*. To commemorate the 100th birthday of the Statue of Liberty, they create a monumentally-scaled banner that is displayed on a tower in Battery Park City as part of the 4 July Independence Day celebrations.

On 7 July, Haring first mentions AIDS in his journal, referring to his friend Martin Buygoyne, who is infected with the HIV virus.[15]

September – Results show that the newly developed drug AZT can slow the progress of HIV. At this time, it is one of the most expensive medicines in history, with treatment costing $12,000 a year, making it inaccessible to many in need. Unfortunately, it is discovered later that it only takes six months for patients to become resistant to the drug.[16]

In October, Haring is invited to paint the west side of the Berlin Wall by a group monitoring human rights violations in East Germany. Though the first six feet (two metres) of land on the western side officially falls under the jurisdiction of the East, Haring continues to paint, hopping back onto western soil whenever border guards approach. The result is a work depicting an interconnected chain of his signature figures in the colours of the German flag. An overt political statement, the mural is an 'attempt to psychologically destroy the wall by painting it'.[17]

**1987**
On 22 February, Warhol dies following a routine operation. Feeling that he has lost both a teacher and his biggest supporter, Haring writes extensively about the importance of Warhol's vision; 'Andy's life and work made my work possible. Andy set the precedent for the possibility for my art to exist. He was the first *real* "modern artist."'[18]

March – activist group ACT UP (AIDS Coalition to Unleash Power) is formed.

As the HIV virus has affected many around him already, Haring is aware much earlier of the chances of his having contracted AIDS. On 28 March, he writes in his journal, 'For I am quite aware of the chance that I have or will have AIDS. The odds are very great and, in fact, the symptoms already exist. My friends are dropping like flies and I know in my heart that it is only divine intervention that's kept me alive this long. I don't know if I have five months or five years, but I know my days are numbered.'[19]

31 May – Over six years into his presidency, Ronald Reagan delivers his first major speech acknowledging the extent of the AIDS epidemic. He is widely criticised for not having acted sooner to slow down the spread of the virus.[20]

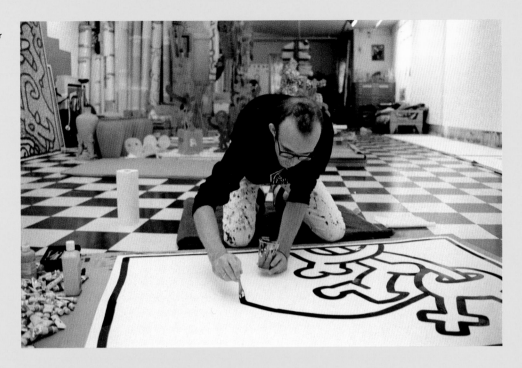

Keith Haring at
his studio, 30 October
1988

Shortly after finding out about Warhol's
passing, Haring goes on a tour of Europe.
Solo exhibitions of his work are held at
Casino Knokke in Belgium (June – August),
where he also creates a mural for its
Channel Surf Club, and at Hans Mayer
Gallery in Düsseldorf (September). Haring
contributes work in the form of a carousel
to Luna Luna, a travelling 'artists'
amusement park and art museum', while
also painting major murals in Antwerp
and Paris.

19 October – The market crash known as
Black Monday occurs on the New York
Stock Exchange, triggering a period of global
economic depression.

8 December – The United States and the
Soviet Union agree to decommission nuclear
missiles in the 3,000–3,400 mile range (the
Intermediate-Range Nuclear Forces Treaty).

**1988**

12 August – Jean-Michel Basquiat dies
of a heroin overdose.

Gran Fury, an AIDS-activist artists collective
consisting of ACT UP members, is
established in 1988. They create the iconic
graphic that combines the pink triangle
symbol with the slogan 'Silence = Death'.

15 *Keith Haring Journals*, 2010, p.131.
16 'AIDS in New York: A Biography'.
17 'Keith Haring Paints Mural on Berlin Wall',
   *New York Times*, 24 October 1986, p.9
18 *Keith Haring Journals*, 2010, p.154.
19 Ibid., p.162.
20 'Remarks at the American Foundation for AIDS
   Research Awards Dinner', 31 May 1987, transcript
   accessed via the Ronald Reagan Presidential Library.
   https://www.reaganlibrary.gov/research/
   speeches/053187a
21 Sheff 1989.

In the summer, Haring starts having
problems with his breathing and becomes
increasingly concerned about his health.
He is diagnosed as HIV-positive soon after.
The same year, his former partner Juan
Dubose dies of an AIDS-related illness.
The physical signs of being HIV positive
lead to Haring being treated differently and
close friends distance themselves from
him. Reflecting on his diagnosis, Haring
states: 'I was here at the peak of the sexual
promiscuity in New York. I arrived, fresh
from coming out of the closet, at the
time and place where everyone was just
wild. I was major into experimenting.
If I didn't get it no one would. So I knew.
It was just a matter of time.'[21]

1 December – The first annual Day Without
Art/World Aids Day.

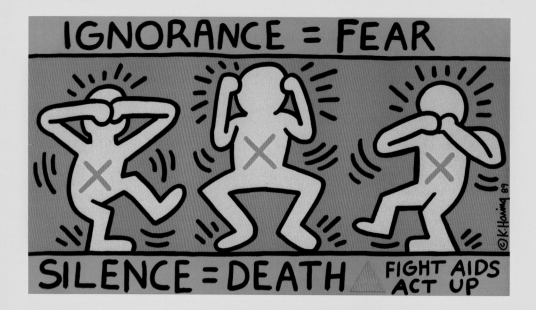

## 1989

20 January – George H.W. Bush succeeds Reagan to become the 41st President of the United States. While his rhetoric relating to AIDS is more sympathetic, Bush, too, is criticised for his lack of action as the epidemic grows.

Haring creates a number of works related to the fight against AIDS, including a 1989 mural in Barcelona, which reads 'Todos Juntos Podemos Parar el SIDA' (Together We Can Stop AIDS). He also joins demonstrations by activist group ACT UP, on one occasion lying down in the road to block traffic (and, subsequently, being arrested).

Haring establishes the Keith Haring Foundation with the mandate to provide funding and imagery to AIDS organisations and those that support marginalised youth, and to continue to expand the audience for his works. While setting up the Foundation, he continues creating

work and protesting in equal measure. On 28 March, he takes part in the ACT UP demonstration at New York City Hall, during which 3,000 people protest New York Mayor Ed Koch's AIDS Policy, which they feel lacks urgency.

Haring continues travelling, showing his work in Europe at solo exhibitions at Gallery 121 in Antwerp (July – August) and Galerie Hete A.M. Hünermann in Düsseldorf, while collaborating with the Beat poet William Burroughs to create a series of screen prints on the theme of the apocalypse for a show at Casa Sin Nombre in Santa Fe, New Mexico.

On 15–18 May, as part of his residency for Chicago public schools and the city's Museum of Contemporary Art, Haring creates a large-scale mural in collaboration with 300 children. Due to the success of the project, the mayor declares it to be 'Keith Haring Week' and, as a result,

the artist offers to paint two murals at a local hospital. Soon after, he paints a mural celebrating homosexuality at The Centre, a lesbian and gay community services centre in Greenwich Village, where the first ACT UP meetings are held.

In June, Haring creates his last outdoor, public artwork, a mural on a church wall in the old city centre of Pisa, Italy. Sponsored by the city and supported by the church, Haring is welcomed with open arms and the work becomes a highlight of his career. Combining familiar motifs such as the figure with a screen for a head and the devil sperm being cut in half, Haring titled the work *Tuttomondo*, in the pastel colours prominently in use on the Renaissance city's buildings, and referring to harmony between everyone in the world.

9 November – Fall of the Berlin Wall.

Keith Haring at
Act Up City Hall Protest,
28 March 1989

### 1990

Towards the end of 1989, Haring stops
taking the drug AZT and tries other
medication to slow the progression of AIDS.
Unfortunately, on 16 February 1990,
following a brief period during which his
health rapidly declined, he succumbs
to AIDS-related complications at the age of
thirty-one. On 4 May, what would have been
his thirty-second birthday, a memorial is
held in New York City, which is attended by
over 1,000 people. By this time, around
90,000 people in America had succumbed
to AIDS-related illnesses, including Haring's
artist friend Tseng Kwong Chi, who
documented the artist's public projects,
leaving a visual account of his life and
his art. On a global level, the virus had
killed an estimated 290,000 people.[22]

22 Thirty Years of HIV/AIDS, amfAR, The Foundation
for AIDS Research, accessed 15 December 18.
https://www.amfar.org/thirty-years-of-hiv/
aids-snapshots-of-an-epidemic/

# Index

Page numbers in *italic* type refer to pictures.

# List of Lenders

ARTIST ROOMS Tate and
National Galleries of Scotland

Benatar Collection

BvB Collection, Geneva

Richard P. Emerson

Esther Grether Family Collection

The Keith Haring Foundation

Kim Jones

Alona Kagan

KAWS

Ludwig Forum für Internationale
Kunst Aachen, loan of the Peter and
Irene Ludwig Foundation

Lune Rouge Collection

Estate of Malcolm McLaren

Julie and Edward J. Minskoff

Editions Enrico Navarra

Noirmontartproduction, Paris

Laurent Strouk, Paris

Spiegelberger Foundation, Hamburg

Stedelijk Museum, Amsterdam

Vasilisa Sukhova

Steve Terry / Wild Life Archive

Estate of Tseng Kwong Chi /
Muna Tseng Dance Projects, Inc.

The Andy Warhol Museum, Pittsburgh

Larry Warsh

Van de Weghe Fine Art, New York

Strauss Zelnick and Wendy Belzberg

and lenders who would prefer to
remain anonymous

*We would also like to thank the following
for allowing us to present their photography
and video as part of this exhibition:*

Charlie Ahearn

Robert Carrithers

Martha Cooper

Jim Hubbard

Baptiste Lignel / Otra Vista

Estate of Fred McDarrah / Getty Images

April Palmieri

John Penley

Joseph Szkodzinski

Testing the Limits Collective
(Gregg Bordowitz, Jean Carlomusto,
Sandra Elgear, Robyn Hutt,
Hilery Kipnis, David Meieran)

Paul Tschinkel

Ande Whyland

James Wentzy

Phil Zwickler, courtesy of Allen Zwickler

# Copyright & Image credits

First published 2019 by order of
the Tate Trustees
by Tate Liverpool
Albert Dock, Liverpool L3 4BB

in association with
Tate Publishing, a division
of Tate Enterprises Ltd,
Millbank, London SW1P 4RG
www.tate.org.uk/publishing

on the occasion of the exhibition
*Keith Haring*

Tate Liverpool
14 June – 10 November 2019

Centre for Fine Arts (BOZAR), Brussels
6 December 2019 – 19 April 2020

Museum Folkwang, Essen
22 May – 20 September 2020

© Tate Enterprises Ltd 2019

A catalogue record for this book
is available from the British Library

ISBN 978-1-84976-627-2

Distributed in the United States and
Canada by ABRAMS, New York

Library of Congress Control Number:
applied for

Project Editor: Alice Chasey
Production: Bill Jones
Picture Research: Bill Jones
Designed by Studio Lorenz Klingebiel
Colour reproduction by Red Repro, London
Printed and bound by Industria Grafica SIZ

Front cover:
Detail of *The Matrix* [pp.36–7]

Frontispiece and colophon:
*Polaroid Self-Portraits wearing glasses*,
painted by Kenny Scharf 1980–1,
Each: 10.8 × 8.8, Collection of
the Keith Haring Foundation

Measurements of artworks are given
in centimetres, height before width